Artisan Breads, Pastries, Cookies, and Desserts

Artisan Breads, Pastries, Cookies, and Desserts

Techniques and Recipes from the Beach Pea Baking Co.

Thomas and Mariah Roberts

PHOTOGRAPHS BY BRIAN SMESTAD :: INTRODUCTION BY JAMES HALLER

Blue Tree
PORTSMOUTH

First published in the United States in 2008
by Blue Tree, LLC
P.O. Box 148
Portsmouth, NH 03802

37 10 1

Copyright © Blue Tree, LLC 2008
Text © Thomas and Mariah Roberts
Design and production: Brian Smestad

All rights reserved. This book, or parts thereof, may not be reproduced in any form without permission from the publisher. The scanning, uploading, and distribution of this book via the Internet or via any other means without the permission of the publisher is illegal and punishable by law. Your support of the authors' rights is appreciated.

Printed in Hong Kong

Library of Congress
Cataloging-in-Publication Data
2008929826

Artisan Breads, Pastries, Cookies, and Desserts:
Techniques and Recipes from the Beach Pea Baking Co.
Thomas and Mariah Roberts
Introduction by James Haller
Includes index.

ISBN-10: 0-9802245-6-X
ISBN-13: 978-0-9802245-6-6

For customer service, orders, and book projects:
Local 603.436.0831
Toll-Free 866.852.5357
Email sales@TheBlueTree.com

www.TheBlueTree.com

Blue Tree
AN ARTISTIC PUBLISHING COMPANY

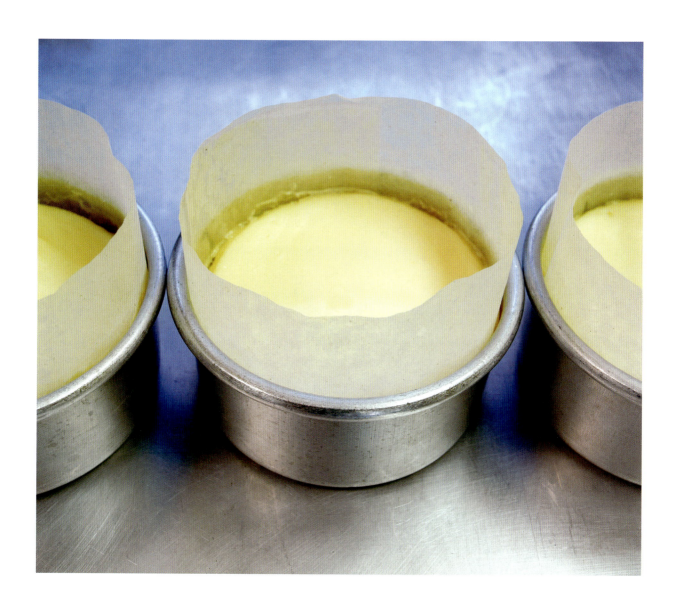

Contents

Foreword by Thomas and Mariah Roberts	ix
Introduction by James Haller	xiii
Useful Terms	xv
Chapter One: Breads	17
Chapter Two: Pastries	27
Chapter Three: Cookies	41
Chapter Four: Desserts	51
Appendix	72

Foreword

Beginnings are sometimes difficult to discern; where, when, and who often blend together when viewed in hindsight. Objectively speaking, Beach Pea Baking Co. opened its doors for business on January 15, 2002—"opened its doors" in the literal sense, for we had actually begun our baking a year earlier, offering our breads and other items at local farmers' markets, in a tent that measured ten feet by ten feet and lacked any doors whatsoever. Farmers' markets gave us an opportunity to become involved with our community, and our canvas tent was a solid environment in which to test our product line. Some of our most dedicated and passionate customers found us at those markets. Those early days of baking were only one beginning, however, for our interest in and dedication to food, service, and community took root over a much longer period.

Our past is inextricably linked with the unique Seacoast community that both our families—comprised of countless entrepreneurs, businessmen and -women, and philanthropists—have called home for twelve generations or more. An incredible sense of altruism, creativity, compassion, and humility permeate the small New England towns that comprise this area. Our present achievements are directly descended from the knowledge and nurturing that was extended to us throughout our years growing up here. So strong are our ties to our community that, though we've traveled and lived elsewhere, we didn't have to think twice about making the Seacoast our permanent home.

From the beginning, we have strived to fulfill two main tenets. First, our products are to be made of only the highest quality all-natural, whole ingredients. Because the Northeast's bounty of fruits, vegetables, and herbs lasts only about four months out of the year, using local products year-round is difficult. We found that the best way for us to support local merchants is to utilize local distributors, and indeed all of our vendors are locally owned and located within the New England region. These vendors are able to supply us with organic dried fruits and grains, unbleached and unbromated flours, regional dairy, and all-natural meats.

To create an environment that caters to our customers and our staff, a place to enjoy visiting and a good place to work, is our second, but equally important, focus. We strive to provide a comfortable, refreshing space for catching up with a friend or grabbing a last-minute baguette for dinner. The individuals working so hard to create this space deserve the same care and devotion. In an industry where such compensation can be seen as a luxury, we have always been committed to providing a living wage and offering necessary benefits such as health insurance and retirement. We, after all, have benefited from the nurturing of our community and have an obligation to do some nurturing in turn.

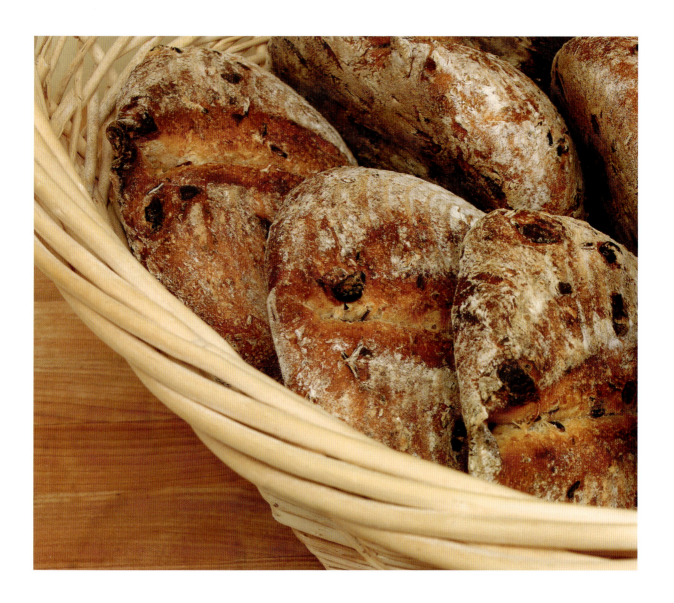

These tenets have moved us forward in accordance with our ideals of producing food in a traditional manner, with time-honored formulas. If this seems easy, we have found that doing something simply is often difficult. Accomplishment has not come without the great effort of numerous people. Dedicated family and friends have often surprised us with dinner left on our porch or an invitation from someone we haven't seen for months due to our relentless work schedule. This is not an easy industry—but it is a rewarding and enlightening way of living life, in which we learn what "early" mornings really are, what "hot" really means.

What began with handcrafted breads and cakes has led to other interests, all founded on the same philosophy that has continued to benefit our organization. With bread comes sandwiches, and with sandwiches come salads, and with salads come soups. Add espresso, coffee, and tea, and you see that "bakery" fails to identify who we've become. Simply put, we have chosen food as our means to embrace the need for stronger communities, healthier people, and a healthier planet. With our latest initiative, commercial composting, we hope to continue to improve our community and hope that our efforts inspire those around us to embrace good stewardship.

We would like to thank you, the dedicated individuals who have supported our endeavors and enjoyed what we are so proud to create. The following recipes are but a glimpse into the craft that goes on in our kitchen every day. Some are staples of our diet, others a bit more indulgent. Try them. With some time and practice, success will be yours.

—Thomas and Mariah Roberts
April 11, 2008

Introduction

The first time I walked into Beach Pea Bakery, I knew something wonderful had happened in Kittery, Maine. I resolved to introduce myself to the baker to express my appreciation. "The baker" turned out to be two bakers, Thomas and Mariah Roberts. When I asked how they had come to create all this—indicating the case filled with chocolate, raspberry, and traditional croissants; beautifully decorated strawberry-filled cakes; lavender cookies; tiny cheesecakes; and elegant fruit tarts—they confessed that neither of them had ever been to cooking school. As a self-tutored chef, I felt an immediate affinity. Behind the cash register, shelves displayed the morning's baking: hot out of the oven, all European-style, fresh, hand-formed breads, baguettes, whole grains, and, my especial favorite, fougasse (made with a rosemary dough, brushed with olive oil, sprinkled with sea salt, and formed like a giant's hand, it is the bakery's most popular bread).

I am always drawn by the optimism of people who dare to take the economic risk of opening their own business, especially their willingness to gamble on an avocation to cook. Beach Pea was an instant success, attracting customers not just from Kittery and Portsmouth, but from surrounding towns as well. To stop in early on a summer morning for a *petit déjeuner*—a baguette or maybe a croissant and a cup of black coffee—and eat it sitting outside on the front porch (the bakery used to be a private home) considering the progress since your last visit of the lovingly cultivated flower and herb border that runs along the front, is an experience to satisfy any lover of good food and the simple pleasures of eating.

With only the two of them on the payroll when they first opened their doors in January 2002, six years later Beach Pea has expanded to employ twenty-seven people. In addition to their culinary artistry, Thomas and Mariah are part of a new generation of bakers and chefs who take their proficiency not only into the world of health but also into the health of the world. It is an admirable commitment! The ingredients they use in their cakes and breads, sandwiches, pastries, and soups are always all-natural and are organic whenever possible. Through the use of natural sweeteners and organic dried fruits and grains, they fulfill the expectations of their customers in ways that truly nourish them.

American chefs and bakers have always taken the know-how from all the kitchens of the world, refining them into combinations that intrigue, delight, and surprise even the most sophisticated diner. Bakers like Thomas and Mariah Roberts are local practitioners of a remarkable movement to link such culinary inventiveness to a concern for the impact their business has on the earth that sustains us all.

—James Haller

Useful Terms

Autolyse. A French term for giving the dough a rest.

Baker's Peel. If you don't have a baker's peel, you can use a baking pan without an edge.

Bulk Fermentation. The stage in the bread-baking process, after mixing and before dividing, that allows yeast, gluten, and acids to develop. Finished dough is placed in the refrigerator for at least 4 hours and up to 2 days.

Couche. A French term translated as "layer," it denotes a heavy linen cloth used in the proofing of traditional breads. Linen is superior to cotton for its ability to repel moisture and prevent dough from sticking to its surface.

Lamé. A French term defining a tool used in traditional bread baking to create slashes on proofed loaves prior to baking; a thin handle approximately 4 inches long supports a traditional razor blade on one end.

Poolish. A mixture of flour and water, plus yeast, allowed to ferment for 6 to 12 hours to develop gluten and beneficial acids. The poolish is developed when small uniform bubbles are active and creases appear across the surface.

Ribbon Stage. Sugar and eggs whipped together reach a point when a utensil lifted out leaves a ribbon.

Signature Secrets. An all-natural stabilizer derived from wheat. It dissolves in both hot and cold liquids.

Water. Water quality and temperature will affect bread's quality. Pure, filtered water is preferable, with an approximate temperature of 65°F.

Water Bath. The placement of a baking dish within a larger pan. Prior to baking, the larger vessel is filled with water to a level that is half the height of the smaller dish. This method is crucial in the prevention of overbaking items with a high liquid content and/or a large-diameter baking dish.

Equipment

General. Measuring cups and spoons, various sizes of mixing bowls, parchment or wax paper, mixing spoons and spatulas, various storage containers.

Bread. 5- or 6-quart stand mixer with dough hook, baking stone, couche, razor blade, sheet pan with no lip, loaf pan, large plastic bag, digital thermometer.

Pastries. 5- or 6-quart stand mixer with paddle and dough hook attachments, 9-inch bundt pan, sheet pan, muffin pan with liners, rolling pin, yard stick, 8-inch chef's knife, vegetable grater or food processor.

Dessert. 5- or 6-quart stand mixer with paddle and whisk attachments; four 6-inch or two 8-inch cake pans; 4-inch, 7-inch, or 9-inch springform pan; sheet pan with lip; wire cooling rack; pastry bag with coupler; pastry tips #2 and #5; stockpot; double boiler; decorating spatulas; small sieve; corrugated cake rounds; pastry brush; serrated knife; digital thermometer.

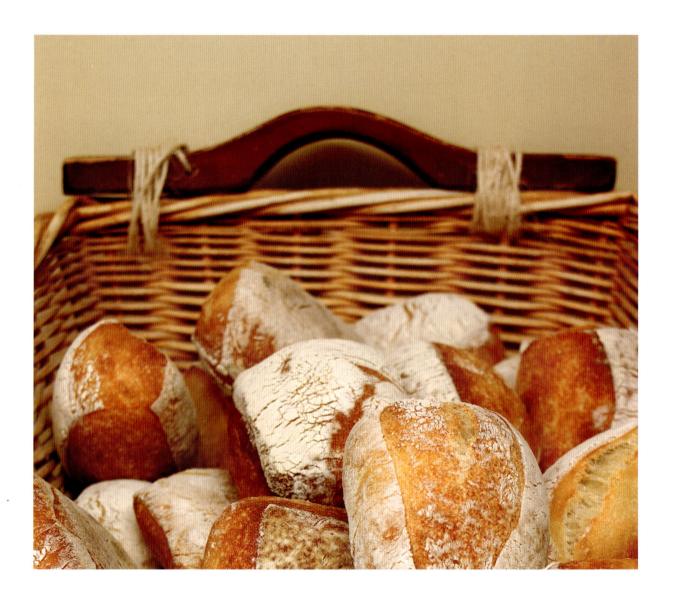

Breads
Chapter One

Bread: this seemingly simple concoction of flour, water, and yeast was our beginning. The start of our journey, the start of our day, the start of our meal. There may arguably be no greater cultural embrace of a single food than that reserved for bread. Countless cultures, countries, and faiths have created and nurtured time-honored traditions that rely on this humble pleasure to add sustenance to their identities and beliefs. In at least one case, bread has been promoted to national icon. It's been part of our lives for so long now that it has become ubiquitous, even taken for granted.

Indeed, during the better part of the past century, delicious traditional breads were phased out to make way for the new mechanized-bakery world of bleached, soft, bland loaves. Fortunately for Thomas and me, this was not the bread we were raised on. We were lucky. Our families sought out the small, creative, independent bakers who woke every morning to put their lives into baking our bread. Struggling against a wave of corporate bakeries filling the growing demand for "stale-proof" white loaves, these bakers endured a dark period in our country's gastronomic history. Fresh loaves of anadama and marble rye—we took for granted what they were struggling to preserve. We made sandwiches, toast, French toast, and croutons and cleaned many a dinner plate with our daily bread.

Now we're surrounded by unlimited options for great food, but a short time ago fresh baguettes were only for those able to fly to Paris, and ciabatta was still hiding out in Puglia, the "boot heel" of Italy. Great bread comes in many a shape, flavor, and texture. Our experiences with food throughout the years have both expanded and focused our understanding of that.

Practice, patience, and persistence are helpful attributes to embrace when baking bread. Ingredients and equipment are the other factors in the equation, and although ingredients eclipse equipment in importance, some basic tools will help you along the way. A metal bench scraper, baking stone, linen towel or couche, spatulas, measuring spoons, and some medium-sized glass or stainless bowls will be more than sufficient for supplies. When sourcing your ingredients, keep personal and environmental health at the forefront of your thoughts. Use unbleached and unbromated flours, and buy organic when available and feasible, especially when utilizing dried fruits, as that is the only way to avoid nitrites and sulfates. There is no need to use anything artificial in baking. Great bread is made from simple, high-quality ingredients.

Brioche

3 cups bread flour
⅓ cup whole milk
2½ tablespoons white sugar
2½ teaspoons yeast
1 teaspoon fine sea salt
4 whole eggs
½ cup plus 1 tablespoon butter, Euro 83%
¼ cup dried cranberries, unsulfured
¼ cup golden raisins, unsulfured

Citrus Glaze
2 cups confectioner's sugar
Juice of 1 orange

Makes two loaves or eight sweet rolls

Mixing

Total time: 3 hours (includes citrus glaze) | Prep time: 15 minutes

1. Allow eggs and butter to warm to room temperature, but do not let butter separate. Measure and set aside dried cranberries and golden raisins.
2. Measure and combine in a mixing bowl: flour, sugar, salt, and yeast. Measure the milk and add it to the bowl, then add the eggs. Slowly begin mixing. Continue mixing on a slow setting until the ingredients form a homogenous but rough dough, approximately 4 minutes.
3. Increase mixer speed to medium and continue mixing for 2 minutes. Stop the mixer, and cut the butter into small pieces. Restart the mixer and leave it on slow, adding the butter to the dough gradually. Once all the butter is in the bowl, increase the speed to medium and continue mixing for approximately 4 minutes, stopping the mixer periodically to scrape down the sides of the bowl with a spatula or plastic dough scraper. This will ensure the proper development of all ingredients.
4. When the dough has become smooth and tight, stop the mixer and add the dried fruit. Continue mixing on low-to-medium speed until the fruit is evenly distributed.
5. Stop the mixer, remove the dough from the bowl, and place it in an airtight container or covered bowl that has been lightly coated with pan spray. Place in the refrigerator for at least 4 hours and up to 2 days.

Baking

Oven temperature: 375°F | Baking time: 18 minutes for buns and 45 minutes for loaves

1. This mix will produce enough dough to create either two loaves or eight individual sweet rolls. Prior to shaping, some

preparation is needed. Please refer to the recipes for cinnamon-sugar (*see page 34*) and citrus glaze (*see below*).

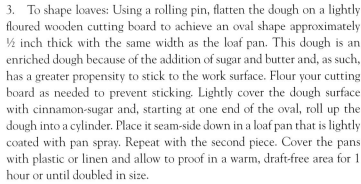

2. Remove the dough from the refrigerator and dump it onto a lightly floured wooden cutting board. To create two loaves, simply cut your dough in half and shape each half into a ball. For individual buns, cut the dough in half, then half again, and finally half again, to create eight similar pieces. Cover the dough with plastic or linen and allow it to rest for 10 minutes.

3. To shape loaves: Using a rolling pin, flatten the dough on a lightly floured wooden cutting board to achieve an oval shape approximately ½ inch thick with the same width as the loaf pan. This dough is an enriched dough because of the addition of sugar and butter and, as such, has a greater propensity to stick to the work surface. Flour your cutting board as needed to prevent sticking. Lightly cover the dough surface with cinnamon-sugar and, starting at one end of the oval, roll up the dough into a cylinder. Place it seam-side down in a loaf pan that is lightly coated with pan spray. Repeat with the second piece. Cover the pans with plastic or linen and allow to proof in a warm, draft-free area for 1 hour or until doubled in size.

4. To shape sweet rolls: Using the palms of your hands, roll each piece into a long cylinder approximately the thickness of a cigar. Spray all pieces lightly with water and dredge in cinnamon-sugar. Remove each piece from the cinnamon-sugar and roll it into a pinwheel, tucking the end underneath the piece. Place on a parchment-lined baking pan that has been lightly coated with pan spray and cover with plastic or linen. Proof as above.

5. During proofing, place one oven rack in the middle position, one rack on the bottom with a baking dish, and preheat the oven to 375°F. When the dough has doubled in size, remove the plastic or linen. Draw a quart of water. Open the oven, place the pan(s) on the middle rack and pour water into the preheated baking dish. Immediately close the oven door. Bake 35 to 40 minutes for loaves or 18 to 20 minutes for rolls. Remove from oven and let cool. Drizzle citrus glaze over the top and enjoy.

CITRUS GLAZE

1. Measure confectioner's sugar and place it in a bowl. Sift if needed. Zest one orange and combine with the sugar. Juice that same orange and whisk the juice into the sugar. If for some reason the orange is extra-juicy, add a little more sugar to get the correct consistency: loose enough to drip across the loaves, but not so thin that it would drip off the loaf.

Fougasse

Poolish
½ cup plus 2 tablespoons water
1 cup (light) flour
⅛ teaspoon yeast

3¾ cups bread flour
1⅓ teaspoons yeast
1 cup plus 1½ tablespoons water
1 (heavy) teaspoon malt syrup
1 tablespoon fine sea salt
1 tablespoon rosemary leaves, dried
¼ teaspoon ascorbic acid powder

Makes two loaves

Mixing
Total time: 12 hours to 2 days | Prep time: 2¼ hours

1. This dough requires a poolish pre-ferment to be made ahead of time. You may mix the poolish the previous day, allowing it to develop for 2 hours at room temperature, then refrigerating; or you may mix the poolish the same day as the dough and allow it to develop for 6 hours at room temperature.
2. Measure the flour and yeast and combine them in a mixing bowl. Add the poolish. Measure the water and stir the malt directly into the water to dissolve it. Add this to the mixing bowl.
3. Start the mixer on low speed. Continue mixing on slow for 4 minutes, until the ingredients have formed a homogenous but rough dough.
4. Stop the mixer. Leaving the dough in the bowl, cover it loosely with plastic and allow it to rest for 15 minutes for the autolyse.
5. During the autolyse, measure out the sea salt, ascorbic acid, and dried rosemary leaves. Set aside.
6. After the autolyse is complete, remove the plastic and add the remaining ingredients. Start the mixer slowly and continue mixing on medium for 4 minutes. When finished, the dough should be smooth and lift cleanly from the bowl, with the rosemary evenly distributed.
7. Place the finished dough in an airtight container or covered bowl that has been lightly coated with pan spray. Place in the refrigerator for at least 4 hours and up to 2 days. Two hours into bulk fermentation, gently push down, stretch, and fold the dough. Cover again and return it to the refrigerator.

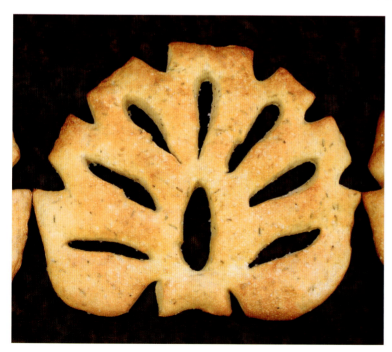

Baking

Oven temperature: 475°F | Baking time: 12 to 15 minutes

1. Remove the dough from the refrigerator and dump it onto a lightly floured wooden cutting board; divide in half with a bench scraper or kitchen knife. Round each half into a ball shape. Place each round onto a baking sheet, lightly brush with olive oil, and cover with plastic. Allow them to rest in a warm, draft-free area for 1 hour.
2. Place the baking sheets on a stable surface such as a countertop or table and remove the plastic. With firm and even pressure, flatten each round into a circle approximately 10 to 12 inches in diameter and ½ inch thick. Cover again with plastic and allow them to proof for 1 hour in a warm, draft-free area.

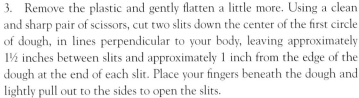

3. Remove the plastic and gently flatten a little more. Using a clean and sharp pair of scissors, cut two slits down the center of the first circle of dough, in lines perpendicular to your body, leaving approximately 1½ inches between slits and approximately 1 inch from the edge of the dough at the end of each slit. Place your fingers beneath the dough and lightly pull out to the sides to open the slits.
4. The cuts will form two "halves" to your dough—they will stay connected! Starting on the top third of one half, cut one slit at a 45° angle upward, from center to edge. Leave ½ to 1 inch between the cut and center cuts and between the cut and the edge of dough. Repeat twice more, cutting through the middle and bottom thirds of the dough. Repeat these steps on the other "half" of the dough creating a mirror of the first "half". There should now be a total of eight cuts in your dough, all of similar length.
5. Starting at the top of the dough (furthest from you), snip ½-inch cuts in the edge of the dough between the ends of each previously cut slit. Do this all the way around your dough; you should have a total of eight cuts around the edge. As simple as this may seem, you will find it difficult at first to be consistent and uniform. Practice and persistence are the keys to improvement. Place your fingers under the dough edge on each side of your piece and gently pull apart to open all cuts and create the distinct "leaf" shape. Uniform, balanced cuts are key to making this bread look great. Gently brush the surface with olive oil and sprinkle with coarse sea salt. Cover each fougasse with plastic and allow them to proof for 1 hour.
6. During the final proof, preheat the oven to 425°F, placing two baking racks in the center positions of your oven. After the final proof, remove the plastic and place a baking sheet on each oven rack. The baking time is approximately 15 minutes, or until the bread is golden-brown. Immediately after baking, brush the fougasses with a final light coat of olive oil. Allow to cool, and enjoy.

Mulit-Grain

2½ cups white bread flour
2½ cups coarse whole wheat flour
2 cups water
1 tablespoon fine sea salt
1⅔ teaspoons yeast
⅛ teaspoon ascorbic acid powder
2 teaspoons malt syrup
3 tablespoons sesame seed
3 tablespoons flax seed
3 tablespoons whole wheat berries
3 tablespoons plus 1 teaspoon organic quinoa
Linen for final proofing

Makes two loaves

MIXING

Total time: 6 hours to 2 days | Prep time: 2¾ hours

1. The day before mixing, place the quinoa and wheat berries in an airtight container or bowl. Fill with water to twice the depth of the ingredients and cover; the ingredients will hydrate overnight.
2. Next day, spread the sesame and flax on a baking sheet and place in a preheated 350°F oven for 20 minutes or until lightly browned and fragrant. Remove and let cool.
3. While the seeds are toasting, thoroughly drain the quinoa and wheat berries, using a fine mesh colander, and set aside.
4. Measure the flours and yeast and combine in a mixing bowl. Measure the water and add the malt syrup.
5. Run the mixer on low for 3 minutes until the ingredients have formed a homogenous but rough dough. Stop the mixer. Lightly cover the bowl with plastic and allow the dough to rest for 15 minutes for the autolyse.
6. After the autolyse is complete, add the sea salt and ascorbic acid to the dough. Start the mixer slowly, increasing the speed to medium. Mix the dough for an additional 3 minutes.
7. Stop the mixer. Add the grains and seeds to the mixing bowl. Start the mixer slowly and mix on low speed until the ingredients are uniformly incorporated, 1 to 2 minutes.
8. Stop the mixer and remove the dough. Place the finished dough in an airtight container or bowl that has been lightly coated with pan spray. Cover and place in the refrigerator for at least 4 hours and up to 2 days. Two hours into the bulk fermentation, gently push down, stretch, and fold the dough. Cover and return to the refrigerator.

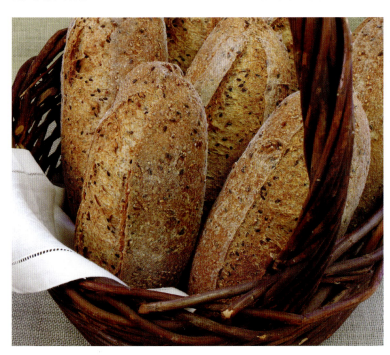

BAKING

Oven temperature: 425°F | Baking time: 25 to 30 minutes

1. Remove the dough from the refrigerator, dump it onto a lightly floured cutting board, and divide it in half. Round each half into a ball shape, cover, and allow to rest on the cutting board in a warm, draft-free area for 1 hour.
2. Treating each round the same, flatten them into ovals approximately ½ inch thick. The oval shape should run from side to side lengthwise. Fold the top third of the dough down. Fold 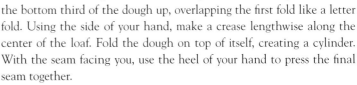 the bottom third of the dough up, overlapping the first fold like a letter fold. Using the side of your hand, make a crease lengthwise along the center of the loaf. Fold the dough on top of itself, creating a cylinder. With the seam facing you, use the heel of your hand to press the final seam together.
3. Place the dough seam-side down. With the palms of your hands on top and your thumbs facing you, rock the dough back and forth with downward pressure to seal the bottom seam. Continue rocking back and forth until your dough resembles a small football in shape.
4. Place the dough, seam-side up, on a couche lightly floured with rice flour. Gather enough linen to create a "wall" between the two pieces of dough. Cover with more linen and let proof for approximately 2 hours, or until doubled in size. Then uncover and gently roll or place the dough pieces onto a baker's peel, seam-side down.
5. Gently dust off any remaining rice flour with a dry pastry brush. With a razor-sharp paring knife or lamé, use one deliberate stroke to slash the dough lengthwise at a 45° angle, knife blade parallel to the baker's peel, creating a lip of dough just off center from the axis of the dough.
6. About 1 hour into final proof time, preheat oven to 425°F, one rack on the very bottom and one rack placed in the middle position. During preheating, place a baking dish on the bottom rack and a baking stone on the middle rack. Measure 1 quart of cold water and set aside.
7. With the proofed and slashed dough and the quart of water close at hand, open the oven door, slide the dough onto the baking stone, pour the water into the baking dish, and close the oven door. The faster you can accomplish this, the better your oven heat and steam will be.
8. Baking time is approximately 35 to 40 minutes; resist the temptation to open the oven door during that time. Finished loaves will have a hollow sound when tapped on the bottom. For more accuracy, an instant-read digital thermometer should read 200°F when inserted into the bottom of the loaf.

French Baguette

Poolish
½ cup water
¾ cup flour
⅛ teaspoon yeast

3 cups white bread flour
1 cup water (light)
2 teaspoons fine sea salt
¼ teaspoon ascorbic acid powder
1⅓ teaspoon yeast (instant active or rapid rise)
1 teaspoon malt syrup
Linen for final proofing

Makes two loaves

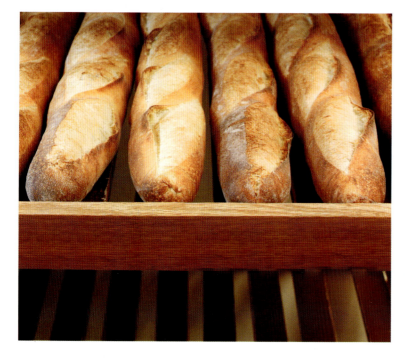

Mixing
Total time: 12 hours to 2 days | Prep time: 2¼ hours

1. Combine the ¾ cup flour and ½ cup water in a clean mixing bowl. Sprinkle the yeast onto the mixture and using your hands or a spatula, mix into a homogenous slurry. Cover and allow 6 hours for fermentation. You may place the poolish in the refrigerator after 2 hours (time can vary depending on ambient temperature) if you will be using it the next day.
2. Measure and combine the bread flour and yeast in a mixing bowl. Use a spatula to scrape all the poolish into the bowl as well. Measure the water and add the malt directly to dissolve. Add to the mixing bowl.
3. Mix on slow speed for 4 minutes, until ingredients have formed a homogenous but rough dough. Stop the mixer. Leaving the dough in the bowl, lightly cover with plastic and allow to rest for 15 minutes for the autolyse. After the autolyse is complete, measure the sea salt and ascorbic acid and add them to the dough. Start the mixer and continue mixing on medium for an additional 4 minutes.
4. Stop the mixer and remove the dough. Place the finished dough in an airtight container that has been lightly coated with pan spray. Place in the refrigerator for at least 4 hours and up to 2 days. Two hours into bulk fermentation gently push down, stretch, and fold the dough. Cover and return to the refrigerator.

Baking
Oven temperature: 475°F | Baking time: 18 to 22 minutes

1. Remove the dough from the refrigerator, dump it onto a lightly floured cutting board, and divide in half. Shape each half into

small logs, approximately 7 inches long, 3 inches wide, and 2 inches high. Cover the dough and allow it to rest on the cutting board in a warm, draft-free area for 1 hour.

2. Treating each piece the same, flatten them into ovals approximately ½ inch thick. The oval shape should run from side to side lengthwise. Fold the top third of dough down. Fold the bottom third of dough up, overlapping the first fold like a letter fold. Using the side of your hand, make a crease lengthwise along the center of the loaf. Fold the dough in half, on top of itself, creating a cylinder with the seam facing you. Use the heel of your hand to press the final seam together.

3. Place the dough seam-side down. With the palms of your hands on top and your thumbs facing you, rock the dough back and forth with downward pressure to seal the bottom. Place the heel or palm of one hand in the center of the dough. Roll the dough back and forth with downward pressure to create a diameter of 1 to 1½ inches. Place both palms on the dough, one on each side of the center. Roll the dough back and forth with downward pressure and slight outward pressure to achieve the 1-to-1½-inch diameter the entire length of the piece. Make sure the length of the baguette does not exceed the length of your baking stone.

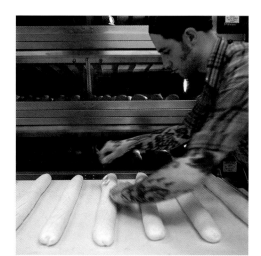

4. Place the dough pieces, seam side up, on a couche lightly floured with rice flour. Gather enough linen to create a "wall" between the two pieces of dough. Cover with more linen and let proof for approximately 2 hours, or until doubled in size. The warmer the room is, the quicker the dough will proof. Gently roll or place the baguettes onto a baker's peel, seam-side down.

5. During the final proof, preheat oven to 475°F, one rack on the very bottom and one rack placed in the middle position. During preheating, place a baking dish on the bottom rack and a baking stone on the middle rack. Measure one quart cold water and set aside.

6. Dust off any remaining rice flour with a dry pastry brush. With a razor-sharp paring knife or lamé, use even and deliberate strokes to slash each baguette four or five times (depending on the length of the dough) at a 45° diagonal lengthwise. The blade should be as close to parallel to the cutting board as possible, creating "flaps."

7. With the proofed and slashed dough and the quart of water close at hand, open the oven door, pull out the rack with the baking stone, extending it far enough to slide the baguettes onto the stone from the side. Baguettes should bake lengthwise from side to side in your oven. Slide the rack back in. Pour the cold water into the baking dish and quickly shut the oven door.

8. Baking time is approximately 20 minutes; resist the temptation to open the oven door early. Finished loaves will be golden-brown with a firm crust. Allow them to cool on a wire rack.

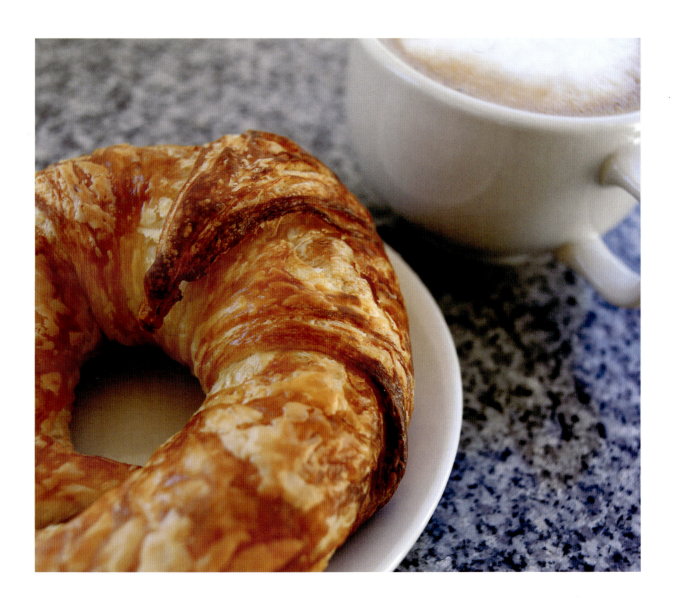

Pastries
Chapter Two

Bakeries are synonymous with the start of our day. They impart comfort to an often rushed commute to work, the beginning of a weekend journey, or a visit to family and friends. Whether you wake to gray skies and rain or that perfect sun-filled morning, the local bakery is the brightest place to start any day.

Coffee and tea may be our morning beverages of choice, to warm us and awaken us, but perhaps their real importance is their other function. Maybe these iconic beverages came to their provenance to accompany that other necessity, a fresh, warm morning pastry. From croissant and Danish to doughnuts and muffins, these little delights can be a meal-on-the-go or a snack during a long conversation with a friend. Imagination is the limit when it comes to taste, shape, and ingredients. Finished with a pat of butter or a dollop of jam, or simply left as they are, these individual treats have consistently satisfied our morning appetites.

Expanding upon traditional recipes, Beach Pea has sought to bring an increased health value to our pastries. Using fresh fruits, vegetables, and natural sweeteners, and substituting fat-free buttermilk for heavy cream, a better balance can be obtained between happy and healthy.

The recipes that follow represent both the classic (our croissant and coffee cake) and classic-with-a-twist (our buttermilk scones and carrot-zucchini muffins). Hopefully this small selection will help to inspire your own morning ritual. It's easy to add different fruits and nuts to a basic scone recipe or add a tasty filling to a croissant. Have some fun, be creative, and make it a great day.

Croissant

5⅔ cups white flour
1 cup pastry flour
¼ plus ⅛ cup white sugar
⅛ teaspoon ascorbic acid
1 egg
¼ plus ⅛ cup buttermilk powder
2¼ teaspoons instant active dry yeast
2½ cups cold water
2½ teaspoons fine sea salt
1 pound of butter

Makes twelve croissants

This project can be done in two days, or stretched to three days for convenience. The process consists of five distinct steps: mixing the dough, preparing the butter, folding in the butter, shaping the croissant, and baking the croissant. None of these steps are very difficult, but it is the act of doing each step correctly and quickly that will create a great final product. The two stages wherein speed is most critical are the folding in of the butter and the final shaping.

Mixing the Dough—Day 1

Prep time: 5 minutes | Mixing time: 15 minutes | Equipment needed: a stand mixer with a dough hook, a sheet pan, and a large plastic bag

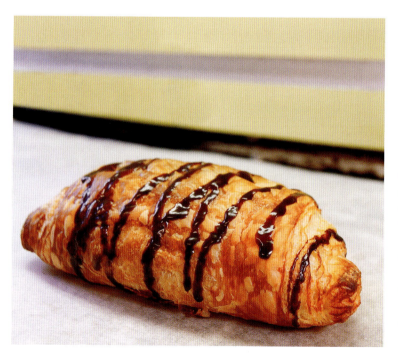

1. Combine all ingredients except the salt in the mixing bowl and mix on low with a dough hook for 2 minutes, or until all ingredients are barely incorporated. Turn the mixer up to medium-high and mix for 2 minutes. Stop the mixer, then add the salt. Mix again on medium-high for 2 minutes.
2. Remove the dough from the bowl and place it on a lightly floured cookie sheet. Flip the dough over once so that it's floured on both sides. Cover with a large piece of plastic or a plastic bag and tuck it under so that no dough is exposed to the air. Place in refrigerator.
3. Four hours later, pull out the dough and unwrap it. Fold the dough in half, creating a rectangle. At this point, press out any air in the dough with your hands. Wrap up the dough and place it in the refrigerator until the following day.

Preparing the Butter—Day 1

Total time: 10 minutes | Equipment needed: a stand mixer with a paddle attachment, a plastic spatula, 12-by-24-inch parchment or wax paper, and a rolling pin

1. The goal of this step is to change the shape of the butter so it will warm evenly when you want to fold it into the dough.
2. Warm 1 pound of butter slightly at room temperature, cube it, and put it into the mixer. Beat the butter until it is all the same consistency but not melted. Fold the wax paper in half so you have a 12-by-12-inch square. Open the paper so you have a top and a bottom. Spread the butter on the bottom half of the parchment. Press down slightly to flatten it and fold the top of the parchment down over the butter. With the rolling pin, gently roll the butter until it's roughly 10 by 10 inches. The goal is to create an even layer of butter, in the shape of a rectangle, about ¼ inch thick. Place the butter in the refrigerator to firm.

Folding Butter into the Dough—Day 2

Prep time: 5 minutes | Folding in butter: 10 minutes maximum | Equipment needed: 1 rolling pin with handles (preferably a heavy marble pin), 1 French pin (a wooden pin that is tapered on either end), a cookie sheet, and a large plastic bag

1. There are many ways to add butter to croissant dough. The process I am about to describe is not one you will find in many books. However, we have found through training many people that this technique produces the most consistent layering and therefore the best final product.
2. Pull the butter from the refrigerator and place it on your counter. Let the butter warm for 5 to 10 minutes. The butter should be soft to the touch in the center of the sheet, but not melted.
3. Once you have achieved this consistency, peel the parchment from one side of the sheet and then replace it on top, then flip it over and repeat the process on the other side. This will free the butter from the paper and will allow it to roll between the two sides of the parchment freely.
4. Using the rolling pin that has handles, gently roll the butter between the two pieces of paper. Be careful to keep the sheet of butter consistent in thickness from the center to the edge. As you get to the edge of the parchment, you will see the butter either split or smear. If the butter splits, this means it is still too cold. Gently peel back the paper and trim the edges, keeping it a rectangle. Place the trimmed pieces in the

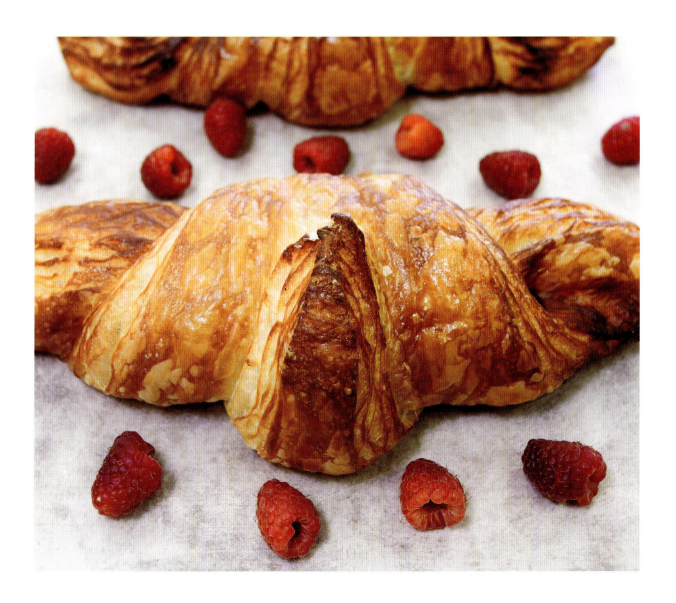

center of the butter sheet and fold the paper back over the top. With the French pin, gently tap the butter into the center. Take the pin with handles and once again roll the butter out to the edges, keeping it in a rectangle. Repeat this process if needed. Once the butter is no longer splitting at the edges, it is ready to get folded into the dough.

5. Remove the dough from the refrigerator and place it on a floured work surface. It is important for the dough to be as cold as possible. Deflate the dough with your hands. With a rolling pin, gently adjust the dough in length and width, maintaining its rectangular shape and an even thickness. The width of the dough should be no more than 1 inch larger than the width of the butter; when you place the butter on top, there should be half an inch of dough visible along the top and bottom. The length of the dough should be one-third larger than the length of the butter. It is easy to see if these proportions are correct by picking up the butter, still wrapped on both sides with the parchment, and placing it on top of the dough. If the piece of dough is too large, gather it in with your hands. Ideally the butter should be 10 by 10 inches and the dough should be 11 by 16 inches.

6. Once the dough is the proper size and shape, take the parchment with the open edge toward you and peel it back. Pick up the butter by the top paper and lay it on top of your dough; position the butter on the first two-thirds of the dough. The sheet of butter will now be bottom-up with the parchment still attached. Gently peel off the parchment paper.

7. With the sides of your hands, crease the dough into thirds. The first and second thirds will divide the butter in half and the last third will have no butter on it. Fold the last third, with no butter, over the second, and dock the edge down into the seam created by the first fold. Slide your hand and wrist under the first third for support and fold it over the other two layers. Adjust the dough, pulling it out at the corners to keep the layers squared off. Pinch together all three layers along the top and the bottom. Pinch together the seam of the long edge to seal the butter folds closed.

8. Leaving the dough in the position it is in, gently roll over it back and forth with your heavy rolling pin, being careful to keep the butter layers consistent during this process. At this point you should only be rolling in the direction of the long seam. Flip the dough on your work surface to keep it from sticking. Roll in this direction until the dough is 24 inches in length. If you have not yet turned it 90°, do it now, and begin to roll the dough in the other direction until it's 12 inches wide. The dough should be about ¼ inch to ⅛ inch thick.

9. With a knife, trim the two outside edges just a little to remove some of the dough that doesn't have any butter in it, then dust off any remaining flour. Once again with the sides of your hands, dock the dough into three even segments. Fold the last third on top of the center section, then fold the first third on top of both.

10. Lightly flour a cookie sheet and place the dough, fold-side down, onto the pan. Cover the dough completely with plastic and place it in the refrigerator. Twenty minutes later, remove the dough. With the long seam facing away from you perpendicularly, once again roll out the dough firmly with the rolling pin, working it out to be 24 inches in length.

11. Once you have achieved the length you are looking for, start to roll the width of the dough until it's 12 inches wide. This time do not trim the dough. With the sides of your hands, dock the dough into thirds and fold once again in the same manner as before. Place the dough back onto the pan, fold-side down, wrap with plastic, and return it to the refrigerator.

12. The dough must now chill for a minimum of 4 hours (maximum of 24 hours) before shaping.

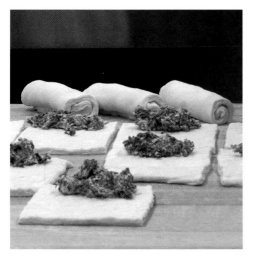

Shaping Croissants—Day 2 or 3

Shaping time: 20 minutes maximum | Equipment needed: 1 heavy rolling pin with handles, a ruler, an 8-inch chef knife, and any filling you choose—ham and cheese, raspberry preserves, chocolate chips, etc.

1. Prep your work station with the utensils, flour, and baking pan. Pull the dough from the refrigerator and place it so the seam runs horizontally. Cut the piece in half. Wrap one half and return it to the refrigerator until you are ready; it's imperative at this point to work quickly, or the butter will melt and it will be impossible to get the dough the proper size and thickness. With your pin, start to roll your dough out. You do not want the butter to escape and get stuck. Keep your work surface lightly floured.

2. First roll the dough front to back with the cut side to the right. If the butter comes out as you roll, just pat it in with plenty of flour. For triangular pieces, roll the dough out to 16 by 18 inches. Place a ruler on top of the dough and divide the piece in half to create two strips 8 inches wide. Cut triangles from these strips, starting on the left-hand side with your knife at a diagonal, with the bases being roughly 6 inches wide. You should end up with eight pieces. Set them aside and clear all of the flour from your work surface. (*Directions for square croissants follow in step 5.*)

[1] To fill with raspberry, stretch the base and place a small amount of preserves in the center of that bottom portion. Carefully fold the dough over the preserves, docking on either side, and continue to roll as above.

[2] If you would like to bake these the following day, consolidate all onto one pan and place it in your refrigerator. In the morning, separate onto two baking pans and proof at room temperature as normal.

3. Spread out the triangles, stretching each one from tip to base, and place next to each other. Stretch each base widthwise[1] and roll up, starting from the base. You will need to apply pressure in an outward direction to try and get some length as you roll. About one-quarter of the way up the roll, switch to holding the base with your left hand and with the right grab the tip and pull the dough out as far as you can without tearing. While continuing to hold in the stretched out position, roll up the rest with your left hand. You want the dough to wrap around at least three times to create the proper look. Triangular pieces are best for plain and raspberry-filled.

4. To finish, curl the two ends towards each other to create the classic crescent shape. Place the croissant on your prepared pan, leaving enough space between croissants for them to double in size. Cover them with plastic and let proof for 2 to 3 hours.

5. For square pieces, roll the dough out to 15 by 19 inches. Cut the dough into three strips, 5 inches wide, then cut each strip into four pieces. You should get twelve pieces. Place your filling on the bottom quarter of the piece of dough, roll over around the filling, and hold with your left hand. With your right hand pull the top of the dough, and roll up the rest of the way with the left hand. Place on the pan with the seam down, cover with a plastic bag, and let proof 2 to 3 hours.[2]

BAKING

Oven temperature: 375°F | Baking time: approximately 20 minutes
Equipment needed: a sheet pan and pastry brush

Preheat your oven and position its racks evenly. You will have reached the proper proof when you press gently on the dough and there is no resistance. They should feel very light and airy and will have at least doubled in size. Brush the croissants with an egg wash and bake for 12 minutes. Rotate the pans top to bottom and front to back and bake for another 5 to 6 minutes, or until golden-brown all over. Pull from the oven and let cool on a rack before eating.

Sour Cream Coffee Cake

Cake

6 cups all-purpose flour
1 tablespoon plus 1 teaspoon baking powder
1 teaspoon baking soda
1 teaspoon sea salt
½ teaspoon nutmeg
16 tablespoons butter, room temperature
2¼ cups white sugar
4 whole eggs, warm
2 cups sour cream, room temperature
2 tablespoons buttermilk
1 tablespoon vanilla extract
½ teaspoon almond extract
2 cups blueberries, thawed if frozen

Cinnamon-Sugar

½ cup white sugar
¼ cup brown sugar
2 tablespoons cinnamon

Makes one large bundt cake

Mixing & Baking

Prep time: 10 minutes | Oven temperature: 360°F | Bake time: 70-plus minutes
Equipment needed: a sheet pan, a pastry brush, mixer, and a 9-inch bundt pan

1. Remove the eggs, butter, and sour cream from the refrigerator to warm. Pull the frozen berries, if you are using them, and allow them to thaw in a sieve. It is very important that all of your ingredients are warm, especially your eggs. This will greatly affect the cake's final volume.
2. Preheat your oven and prep the pan with pan spray. Combine all of the dry ingredients in a bowl and whisk them briefly to incorporate and aerate them.
3. Cream the butter in the mixer on medium speed, until you get a little volume. Add the sugar, scrape down the bowl, and beat again on medium speed for at least 2 minutes—the time will depend on the temperature of your ingredients. The sugar should be breaking down and gaining volume. You want the mixture to be light and fluffy. Scrape the bowl down again.
4. Add eggs, one at a time, as the mixer is running. Stop the mixer and scrape down the bowl in between additions. You are looking for volume at this point. As you are creaming and adding the eggs, gather the other wet ingredients in a bowl and gently whisk to incorporate.
5. Once you have added the eggs and have achieved the volume you're looking for, scrape down the bowl and add the wet ingredients. Mix on medium speed until just combined. Add the dry ingredients in three batches on medium speed. It is very important to scrape down the bowl between each addition; this entire process should take no more than 2 to 3 minutes.
6. Drain any liquid from the frozen berries. Remove the bowl from the mixer and fold in the berries by hand. Quick and deliberate handling of the batter will help to evenly distribute the berries without breaking down the structure of the cake batter.
7. Spoon half of the batter into the bottom of the pan, making sure that the level is even. Sprinkle with a layer of cinnamon-sugar. Spoon the rest of the batter on top and make sure that it is evenly distributed and that all of the cinnamon-sugar is used. Sprinkle with sugar again, and put in the oven immediately.
8. Do not open the door of the oven during the first 60 minutes of baking, or your cake may collapse. Test the cake with a skewer; when it comes out clean, it is done. Remove from the oven and let it cool in the pan for at least 15 minutes. If you're not planning on eating the cake for a day or so, leave it in the pan to help prevent it from drying out.

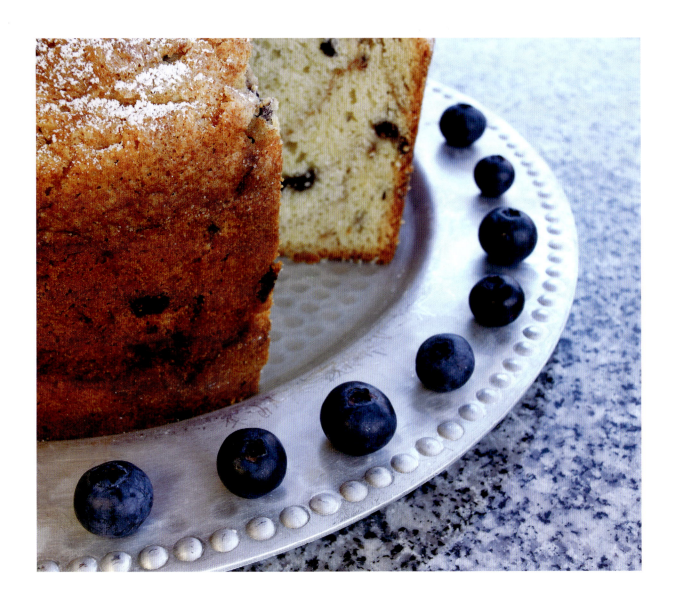

Scones

Scone Mix
6½ cups pastry flour
1½ cups all-purpose flour
1¼ cups white sugar
2½ tablespoons baking powder
2½ teaspoons fine sea salt
13 tablespoons butter, cold, cubed
Each mix yields 2 batches

1X Batch of Scones
5 cups Scone Mix
1 cup filling
2 cups low-fat buttermilk

Each batch makes eight large scones

Creating the Scone Mix

Prep time: 10 minutes | Oven temperature: 400°F | Baking time: 16 to 18 minutes
Equipment needed: a large bowl, plastic spatula, ice cream scoop, and two cookie sheets

Scones are a type of biscuit normally eaten for breakfast or an afternoon snack. The key to making a tender biscuit of any kind is not to overmix. This scone is a little different from the traditional English version made with heavy cream and eaten with clotted cream and jam. We start with the scone mix as a base and are able to incorporate many different kinds of fillings to change the product. We also use buttermilk as the liquid, which keeps the scone very moist and low in fat. The sky is the limit as far as flavors go, so have fun.

1. Combine the first five ingredients in the mixer. Mix ingredients on speed 1, using the paddle attachment, before adding the butter.

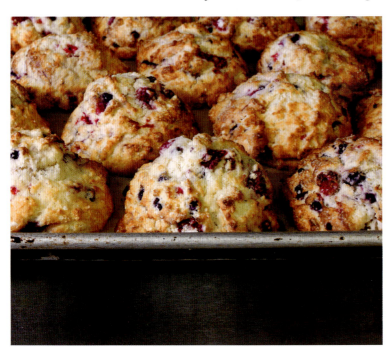

2. As the dry ingredients are mixing, pull the butter from the refrigerator and cut it into ¼-inch cubes. You could also make this recipe by hand, by combining the dry ingredients and quickly grating very cold (almost frozen) butter into it. You would then work the mix together by hand or with a pastry cutter.

3. Add the butter to the mixer as it is running on speed 1. Let the ingredients combine for a few minutes. You may need to stop the mixer a few times to make sure the butter is not stuck in the paddle.

4. Stop the mixer and feel throughout the mixture to make sure all of the butter is broken up evenly. The end result should be pea-size, or smaller, chunks of butter, evenly distributed throughout the scone mix—if the butter has completely incorporated, that is okay. Put the mixture into a storage container and refrigerate until needed.

Mixing & Baking

1. Preheat the oven and prep your baking sheets with parchment paper.
Measure out the scone mix for the batch size you would like to make. Put the scone mix in a large bowl and run your hands through it to break up any large pieces of butter that may still be in it.
2. Measure out your filling and toss it with the dry mix. You want to distribute the filling evenly so that when you add the buttermilk, the least possible amount of mixing is required.
3. Add the buttermilk to the dry mix and fold them together. Focus your mixing on getting to the bottom of the bowl and incorporating the dry ingredients from the sides of the bowl. Stop mixing when there's still a little bit of dry mix not thoroughly combined in the bowl.
4. With an ice cream scoop or a large spoon, portion the scones on your pan. Sprinkle a little sugar on top if desired.
5. Place the pan in the oven immediately and bake for 16 to 18 minutes. Scones are done when they spring back under your fingers or a wooden skewer comes out clean.

Note: if you would like to make smaller scones, simply decrease the baking time.

Filling Suggestions

Mixed berries, candied ginger, almonds, chocolate chips, lemon and dill, or any combination you find appealing.

Another way to jazz up your scones is by using banana purée, pineapple purée, or pumpkin purée as half of your liquid. Use about 1 cup of purée and 1 cup of buttermilk, mix them together, then add them as you would the plain buttermilk.

Carrot Zucchini Muffins

3½ cups all-purpose flour
2 teaspoons baking powder
1 teaspoon baking soda
1 teaspoon fine sea salt
1 teaspoon nutmeg
2 teaspoons cinnamon
1½ cups organic cane sugar (raw sugar)
1 cup pineapple purée
⅔ cup canola oil
4 eggs
2 teaspoons vanilla
1½ cups shredded zucchini
1½ cups shredded carrots

Makes twelve large muffins

Mixing & Baking

Prep time: 20 minutes | Oven temperature: 360°F | Baking time: 30 to 40 minutes

This is our favorite muffin. Without a lot of oil or eggs and with lots of veggies, they are healthy too. There are two tricks to making great muffins: not overmixing the batter and getting them in a preheated oven as soon as they are in the pan.

1. Preheat the oven to 360°F. In a large bowl, mix together all of the dry ingredients except the sugar.
2. In a second bowl, whisk together the sugar, oil, eggs, vanilla, and puréed pineapple.
3. Add the shredded carrot and zucchini to the second bowl. Whisk them together to incorporate evenly.
4. Lightly spray the muffin pan, insert the paper liners, and then lightly spray the paper.
5. Making a small well in the center of the dry ingredients, pour all of the wet mix into the dry mix. With a plastic spatula, fold the ingredients together. Concentrate your folding on the bottom and the sides of the bowl. Look for areas where dry ingredients may be hiding and incorporate them carefully. The batter should be very loose.
6. Stop mixing when there's still a little bit of dry mix not thoroughly combined in the bowl. With an ice cream scoop or a large spoon, portion the batter into the prepared pan.
7. Sprinkle a little sugar to give the muffins caramelized tops. Place in the oven immediately. These muffins do take a little longer (30 to 40 minutes) than the average muffin because of the amount of moisture in the vegetables. They are done when they spring back to the touch and have nice golden-brown tops.

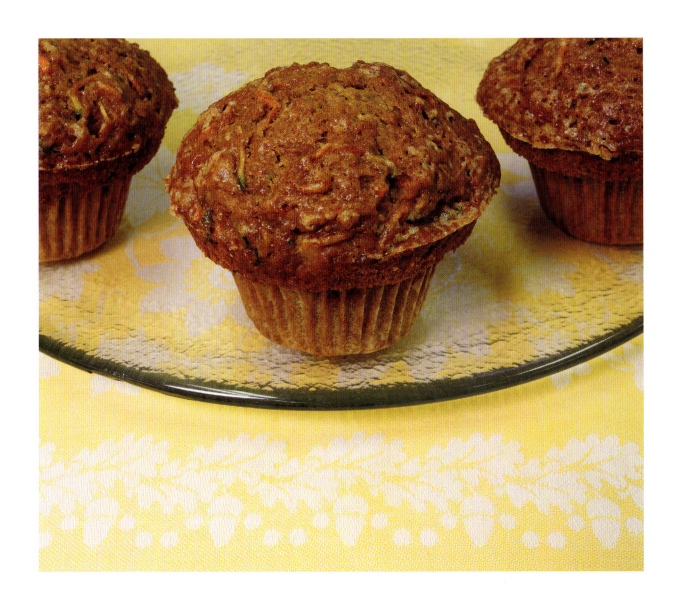

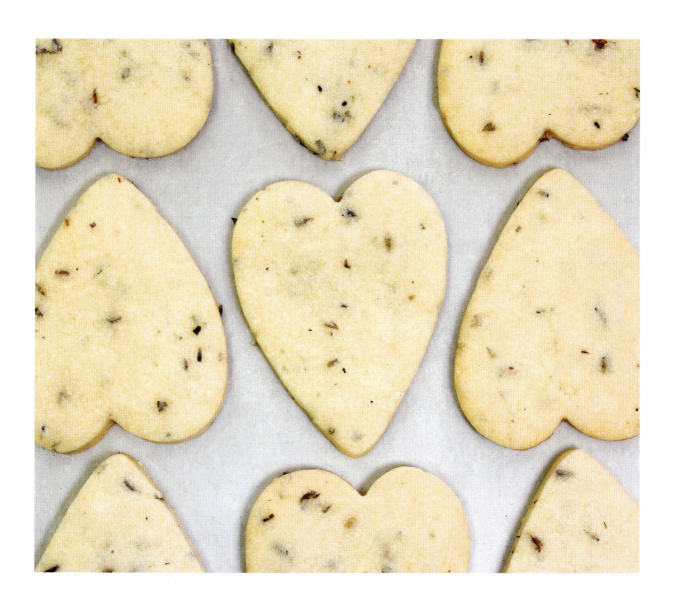

Cookies
Chapter Three

From chocolate chip to hermits, to tuiles and pizzelles, anyway you look at them (or eat them) they are cookies. Individual, comforting, and reminiscent, a cookie is many things to many people. At first you may be inclined to think round, flat, and sweet, and you wouldn't necessarily be incorrect. You would, however, be limiting yourself to only a round world in a universe of many shapes, colors, flavors, and textures. Sweet or savory, chewy or crumbly, you may enjoy them as you wish. Accompanied by fresh milk, espresso, or a glass of wine, they're the hub of a perfect and often much-needed afternoon snack.

By now you are probably aware of our mission to avoid preservatives, hydrogenated shortenings, and artificial sweeteners in our recipes. Some of our ingredients may be new to you and some, such as organic cane sugar and rice flour, may only be found at your local health food store. Use the opportunity to visit the health food store—the individuals working there possess invaluable information about nutrition. The following recipes produce cookies that are unique unto themselves. They are choices to address both classic tastes and recent dietary concerns.

Cookies are a great introduction to baking for you and your children, friends, and loved ones. They're a simple pleasure to enjoy and to bake, but they're not fool-proof. Each recipe has inherent differences with regards to production: different mixing, different baking, different ingredients. You are certain to overmix or overbake your sweet little treats at some point. Worry not, for a little practice goes a long way. Bake some for a special occasion, or simply to fill a rainy afternoon.

Cowgirl Cookies

2½ tablespoons crushed pineapple
1 cup plus 2 tablespoons unsalted butter, softened
3 cups evaporated cane sugar
3 eggs
1½ teaspoons vanilla extract
3½ cups rolled oats
2⅔ cups all-purpose flour
¾ teaspoon baking powder
1½ teaspoons baking soda
¾ teaspoon fine sea salt
⅔ cup semisweet chocolate chips
½ cup chopped walnuts
1 cup coconut (desiccated, no sulfur)

Makes three dozen small cookies

MIXING & BAKING

Prep time: 15 minutes | Oven temperature: 350°F | Baking time: 16 to 18 minutes

1. Combine all dry ingredients except the sugar in one bowl. In a second bowl, combine the chocolate chips, walnuts, and coconut. Set both bowls aside.
2. In a mixer, cream the butter until it's pale and fluffy. Add the pineapple purée and mix on medium speed until combined.
3. Stop the mixer, scrape down the bowl, and add the sugar. Mix together on speed one, stop and scrape down the bowl again, then continue mixing on medium.
4. Add the eggs and vanilla, scrape the bowl, and mix on medium until light and fluffy.
5. Stop the mixer and add the dry ingredients. Pulse the mixer on low until the dough begins to come together. Stop and scrape down the bowl, add the chocolate chips, walnuts, and coconut, and mix again to incorporate.
6. With a large spoon or ice cream scoop, portion the cookie dough onto a sheet pan, leaving enough space for the cookies to double in size. Gently flatten the dough with the heel of you hand for consistent baking.
7. Bake for 16 to 18 minutes, until their edges are light brown. Allow them to cool on the pan for at least 10 minutes before transferring them to a plate.

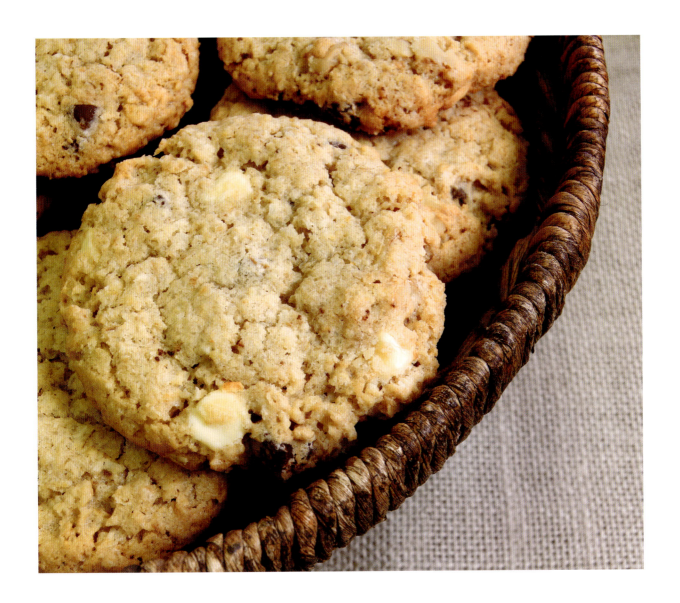

Double Chocolate Chunk

¾ cup semisweet chocolate chips
2½ cups semisweet melting chocolate[1]
10 ounces unsalted butter
6 eggs
2⅓ cups evaporated cane sugar
2 teaspoons vanilla extract
½ cup rice flour
2 teaspoons baking powder
½ teaspoon fine sea salt
3½ cups semisweet chocolate chunks

Makes fifteen large cookies

MIXING & BAKING

Prep time: 15 minutes | Oven temperature: 350°F | Baking time: 15 to 16 minutes

(Gluten-Free)

1. Preheat oven.
2. Using a double boiler or a microwave melt the first two chocolates and butter together.
3. In a mixer, whip together the eggs, sugar, and vanilla to ribbon stage.
4. Add the melted chocolate mixture to the eggs and whip them together. Stop and scrape the bowl and mix until well incorporated.
5. While the above ingredients are mixing, combine the dry ingredients in a separate bowl.
6. Add the dry ingredients to the mixer and combine using the paddle attachment. Stop and scrape the bowl, then add the chocolate chunks. Mix until blended. The batter will be very loose.
7. With a large spoon or ice cream scoop, portion the batter onto a baking sheet and refrigerate until hardened. Once they're firm, they're ready to bake.
8. Arrange them on a pan with enough space for them to double in size and bake for 15 to 16 minutes.
9. These cookies will not look done when they're ready to come out; they're similar to a soufflé. They are done when the edges are firm to the touch but the centers are still gooey. Remove them from the oven and allow them to cool on a pan for at least 15 minutes.

[1]*Melting chocolate contains more cocoa butter and sometimes more cocoa solids. More cocoa butter allows it to melt more easily. With chip chocolate, having less cocoa butter helps it hold its shape. By combining them we create a chocolate with both qualities.*

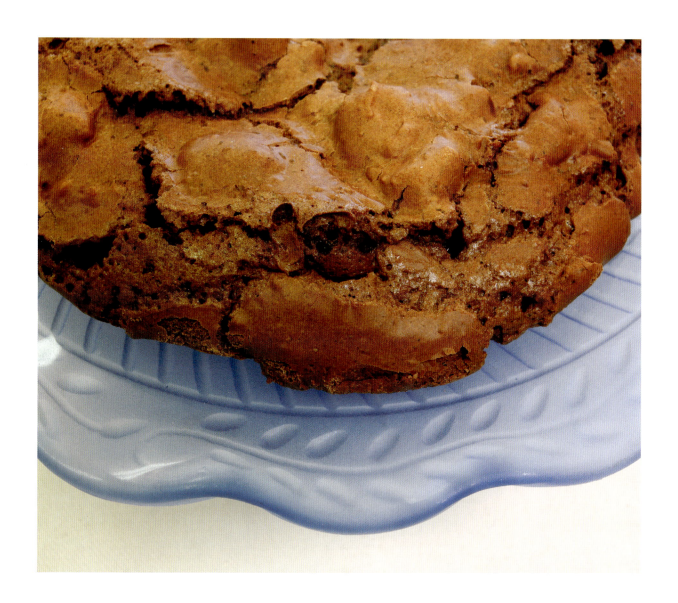

Lavender-Mint Shortbread

1¼ cups confectioner's sugar, sifted
2 tablespoons plus 2 teaspoons dried lavender flowers
1 tablespoon finely chopped fresh mint
4⅓ cups all-purpose flour
1 pound butter, unsalted, cold
1 teaspoon vanilla extract
2 tablespoons plus 2 teaspoons whole milk

Makes five dozen 2-inch hearts

Mixing & Baking

Prep time: 10 minutes | Oven temperature: 350°F | Baking time: 12 minutes
Equipment needed: mixer, rolling pin, sheet pan, and cookie cutter

1. Preheat oven.
2. Measure the sugar and flour into a mixing bowl.
3. Finely chop the lavender and mint, add them to the mixing bowl, and combine on low speed.
4. Cube the cold butter and add it to the mixer slowly while it runs on low speed.
5. With the mixer still running, slowly add the vanilla and milk.
6. Remove the dough from the mixer and place it on a well-floured work surface.
7. Roll the dough to a ¼-inch thickness and press it with a heart-shaped cookie cutter.
8. Transfer the cut-outs to a cookie sheet with a spatula and bake immediately.

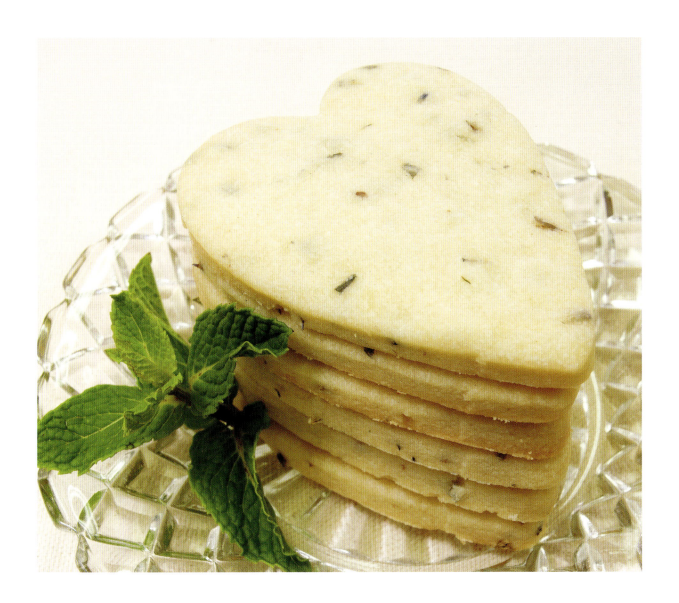

Quigy Bars

6 cups puffed rice
1½ cups whole wheat flour
1 cup evaporated cane sugar
½ cup organic quinoa
¼ cup ground flax seed
2¼ cups chopped organic sultana figs
1 cup pumpkin seeds
1 teaspoon fine sea salt
½ cup unsweetened applesauce
1 cup honey
2 eggs
2 teaspoons vanilla extract

Makes forty-eight 2-inch squares

Mixing & Baking

Prep time: 15 minutes | Oven temperature: 350°F | Baking time: 25 to 30 minutes
Equipment needed: cookie sheet with ¼-to-½-inch lip

1. Preheat the oven.
2. Combine all dry ingredients in a large bowl.
3. Combine the wet ingredients in a mixer and whisk on medium speed until they are well combined.
4. Pour the wet ingredients over the dry and mix them together by hand until all the liquid is absorbed.
5. Spread the mixture into a well-greased pan and smooth it until it's of an even thickness. Place in the oven and bake for 25 to 30 minutes.
6. Once out of the oven, allow the bars to set, invert the pan onto a cutting board, and cut into 2-by-2-inch square pieces.

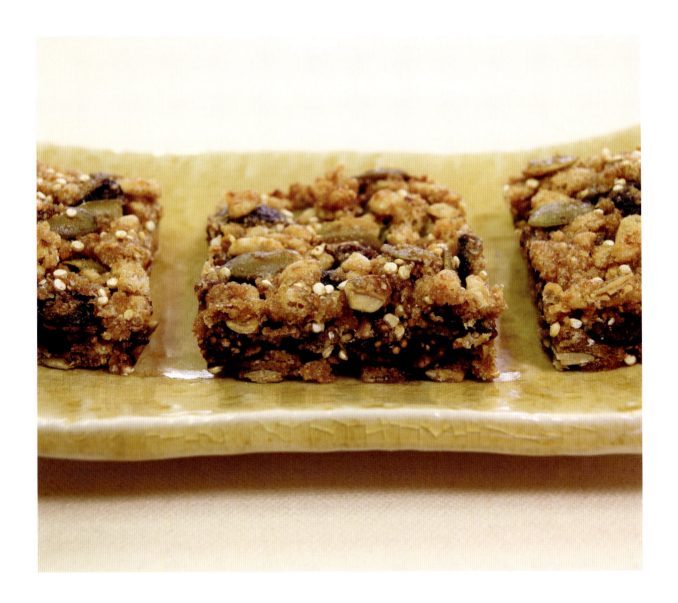

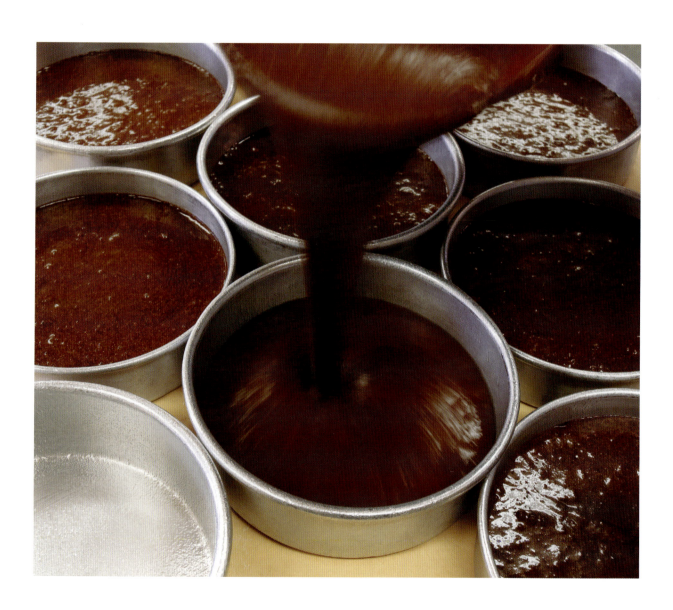

Desserts

Chapter Four

It is fitting to finish this, our four-course book, with a chapter on dessert. The much-anticipated sweet end to a dinner perfectly balances the savory foods that have preceded. Our first desserts here at the bakery were simple, elegant, decorated cakes. Made according to the same principles that imbue other items at Beach Pea, our desserts highlight the quality of their all-natural ingredients and minimize the flashy, often overstated, design elements that have become so prevalent in contemporary cake decoration. Balance is an important quality in food, especially dessert. Too sweet, too heavy, too dry, too bland—these are all sentiments that we have attributed to a dessert or two in our past culinary experiences. It's not enough simply to look good in the world of desserts. We have strived to create great-tasting, beautiful, yet simple cakes and desserts.

In addition to cakes, we also produce smaller desserts for those interested in just a little something. Éclairs, produced using traditional methods and authentic ingredients, have been among our favorites from the beginning. Slices of cake are also popular, with several varieties that our customers can choose from. Whatever the size, craving, or occasion, there is certainly a dessert to fit the need.

Desserts and cakes are often created from a number of complementary components. Use the following recipes as an entry-point. As you progress, allow yourself the artistic freedom to mix it up and layer your pastry cream onto a cake, or fill your pâte choux with mascarpone sabayon. These recipes are simply interpretations.

Éclairs

PASTRY CREAM

Yield: 1½ quarts

¾ cup white sugar

3 tablespoons all-purpose flour

1½ tablespoons cornstarch

3 eggs

1½ cups whole milk

1½ cups heavy cream

10 tablespoons butter, room temperature

1½ teaspoons vanilla extract

CHOUX PASTRY

½ cup water

½ cup whole milk

8 tablespoons butter

½ teaspoon fine sea salt

1¼ cups all-purpose flour, sifted

4 whole eggs

CHOCOLATE GANACHE

Yield: 1 quart

1⅔ cups heavy cream

⅓ cup white sugar

2 cups dark melting chocolate

6 tablespoons butter, cubed, room temperature

White chocolate to drizzle

Makes twenty-four 2½-inch éclairs

PASTRY CREAM

Prepare a day ahead if possible

1. Pull butter from the refrigerator and cut it into 1-inch cubes. Set aside a storage container and the vanilla.
2. Sift together the flour, sugar, and cornstarch in a mixing bowl. Add the eggs and beat until light in color.
3. In a medium-size, heavy-bottomed pot, bring the milk and cream to a boil over medium heat. Be careful, as the cream will boil over very easily.
4. To ensure the eggs are not cooked when adding them to the hot cream mixture, pour half the cream mixture into the eggs in the mixer while on medium speed with whisk the attachment. Then return the egg mixture back to the pot on the stove.
5. Over medium heat, mix the cream with a spatula until it thickens and reaches a temperature of at least 170°F. To avoid burning, it is very important to scrape the bottom of the pot continuously with the spatula. If any burning should occur, remove the pan from the stove immediately and pour the cream into another pot. Do not scrape off the bottom layer. Continue cooking as normal.
6. When the cream is done, it will be bubbling around the edges. The majority of the frothiness will have dissipated, and it will have reduced by about ½ to 1 inch. You should be able to leave trails in it with your spatula.
7. Remove from heat and add the butter and vanilla. Stir until the butter is melted and incorporated. Transfer to a storage container and cover with a layer of plastic wrap directly on top of the cream; this will prevent it from developing a skin. Let it cool on the countertop for 10 to 15 minutes and then refrigerate until set, at least 2 hours.

CHOUX PASTRY

Prep time: 15 minutes | Oven temperature: 430°F | Baking time: 20 to 30 minutes

1. Prepare your pans with pan spray and preheat the oven before you start this project. You will need a pastry bag without a tip, leaving a nickel-size hole. You will also want to line each sheet pan with a piece of parchment paper.

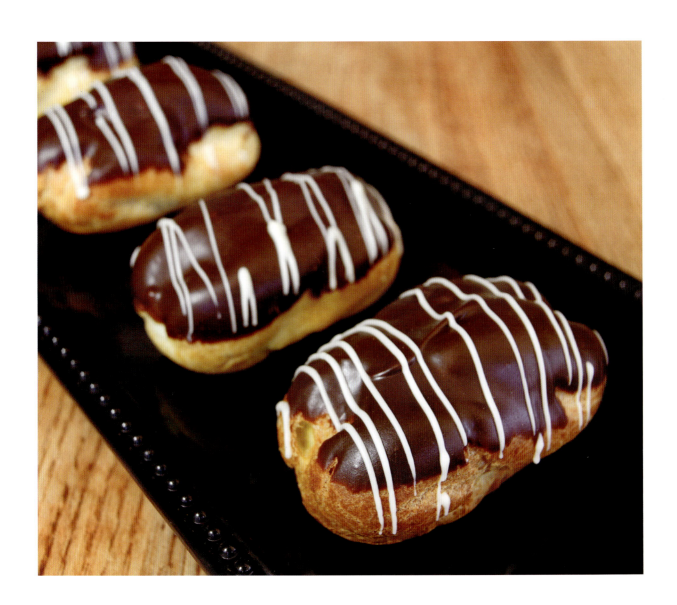

2. Heat the water, milk, butter, and salt over medium heat until it reaches a boil.

3. Remove from heat and add the flour all at once. With a spatula, mix until the flour is incorporated. Return to heat for another 2 to 3 minutes, stirring until the flour is completely combined and the moisture is absorbed. If the butter starts to melt out, it's okay, it will reincorporate.

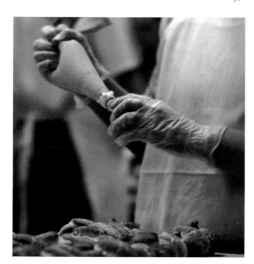

4. Remove from the heat, transfer to a mixing bowl, and let cool for at least 10 or 15 minutes.

5. As the batter is cooling, crack the eggs into a bowl.

6. When the batter is no longer too hot to touch, start beating in the eggs.

7. With the mixer on medium speed, add one egg at a time, stopping to scrape down the sides of the bowl frequently.

8. Once the eggs are incorporated, the batter is ready. Remove from mixer and fill the pastry bag halfway. Take care to avoid getting batter on the side of your bag, for it will be very sticky. Hold the bag by the top and squeeze all of the pâte choux toward the tip, pressing out any pockets of air that may be trapped. Twist up the back of the bag to stop the batter from coming out the back. When using a pastry bag, guide with one hand and apply pressure to the back of the bag with the other; this back hand controls the amount of batter that comes out. To stop the batter from coming out the tip of the bag, let pressure off the back.

9. Begin piping the éclairs onto sheet pans. For small éclairs, make them approximately 2 inches long and the width of the hole in the bag. For a larger éclair, they will be approximately 4 inches long and slightly wider than the hole. (You can achieve this by slowing down as you are piping but keeping the same amount of pressure on the back of the bag.) Try to pipe éclairs evenly on the sheet pan to ensure proper heat circulation and even baking.

10. Place éclairs in the oven and set your timer for 20 minutes. After 20 minutes, quickly check the éclairs by opening the door. This serves two purposes: it allows you to remove the small éclairs if done, but it also releases any steam that has built up in the oven. Steam in the oven will not allow for proper browning of the pastry.

11. Éclairs will be fully browned on all sides when they're done. If they're too close together and are not browning on the sides, shake the pan to adjust the spacing.

12. After the éclairs are fully cooled, use a skewer to poke a pea-size hole in one end of each. Poke through any webbing inside the éclairs, but avoid poking through the other end.

13. You may now assemble the éclairs, or you may bag, date, and freeze them for a later date.

Chocolate Ganache

1. In a double boiler, warm the heavy cream and sugar until the sugar is dissolved.
2. Add the chocolate to the double boiler and stir to dissolve.
3. Add the butter and stir until combined.
4. Pour into a bowl or storage container.

When using on a cake, ganache should be thin enough to pour but not so hot that it slides off the cake. When using on an éclair, it should be slightly stiffer to minimize dripping down the sides.

Éclair Assembly
Equipment needed: pastry bag and coupler, #10 pastry tip

1. Fill a pastry bag with pastry cream. Hold it by the top of the bag and squeeze the cream toward the tip, allowing any air bubbles to escape. Twist the end of the bag closed and hold with your dominate hand.
2. Hold an éclair body with your other hand, insert the pastry tip into the hole, and lightly squeeze cream into the éclair. It will plump in your hand when it is full.
3. Continue this process with the remaining éclairs.
4. Once they're all filled, empty any remaining cream from the pastry bag and store it in the refrigerator. It will keep up to seven days from the date it was made.
5. Warm the ganache to a consistency good for dipping, enough to coat but not drip down the sides of the éclair.
6. As the ganache is warming, use a paper towel to clean up the ends of the éclairs where any cream may have leaked.
7. Dip the top of each filled éclair into the ganache and place bottom-down on a clean baking pan. Continue until all are coated, placing them next to each other in rows on the pan.
8. To finish, warm some white chocolate and, using the tines of a fork, drizzle the chocolate across the tops of the completed desserts.
9. Place the entire tray in the refrigerator and let set, about 20 minutes.

Tiramisu

European Sponge Cake

Use springform pans at least 3 inches tall

1½ cups cake flour
12 egg yolks
½ cup white sugar
2 teaspoons vanilla extract
12 egg whites
½ teaspoon cream of tartar
½ cup plus 2 tablespoons white sugar

Mascarpone Filling

Yield: 2 quarts

1 cup plus ½ cup sweet Marsala wine
6 egg yolks
¾ cup white sugar
2 cups heavy cream
16 ounces mascarpone cheese
1 teaspoon powdered gelatin, unflavored,
OR 3 tablespoons Signature Secrets

Makes two 8-inch cakes

European Sponge Cake

Prep time: 15 minutes | Oven temperature: 350°F | Baking time: 30 to 35 minutes

1. Pull the eggs from the refrigerator to warm. Prepare two springforms or removable bottom pans with pan spray and place on a cookie sheet. Set the oven temperature and arrange the racks for even heat circulation.
2. Sift the cake flour twice, return it to the sifter, and set aside.
3. In a mixing bowl, beat the egg yolks, vanilla, and ½ cup sugar on high speed, until it's thick and pale yellow, approximately 3 minutes.
4. Scrape the egg mixture into a large bowl, sift the cake flour over the top, and do not mix.
5. Beat the egg whites and cream of tartar on medium speed until soft peaks form; they should remain smooth and glossy. Gradually add ½ cup plus 2 tablespoons sugar while beating on high speed. Beat to stiff peaks, but not dry. The egg whites should still be shiny.
6. Fold one-third of the egg whites into the bowl containing the flour and the egg yolk mixture, and do not mix completely. Add the remaining egg whites in two additions, folding and scraping the sides as you go. It is very important not to overmix.
7. Portion the batter into pans on the cookie sheet and place them in the oven as soon as possible. With a spatula, gently spread the batter to the edges of the pans. It doesn't need to be completely flat; the batter will flatten out in the oven, and you will retain more volume in your cake.
8. Bake until the tops of the cake spring back when pressed. The tops of the cakes will be golden-brown, and a skewer should come out clean. When the cakes are done, remove them from the oven and place them on a cooling rack. Let them cool in their pans for 10 to 15 minutes.

Note: This recipe makes two cakes. If one cake doesn't achieve enough volume while it bakes to cut into four layers, you can use the second cake to augment the first. If you don't happen to need the second cake, however, you can freeze it for later use. This is also the same cake batter that traditional lady fingers are made from. They are formed using a pastry bag and piped directly on a sheet pan to bake. Sift the tops of the lady fingers with confectioner's sugar and place in oven. Bake for 10 to 15 minutes, until golden-brown.

Espresso Soak

If you have an espresso machine, brew at least 2 cups. If you don't have an espresso machine, use instant crystallized espresso; you will need about 2 cups.

Mascarpone Cheese Sabayon
Total time: 1 hour

1. Remove the mascarpone from the refrigerator to warm. In a stainless steel bowl, mash the cheese from its packaged form. This will help it warm and incorporate more quickly.
2. Combine the sugar and egg yolks in a mixing bowl and whisk until light and fluffy. Add 1 cup of Marsala and whisk until incorporated.
3. Place the egg yolk mixture in a double boiler. Continually whisk the mixture until it's thick and foamy; this is called a sabayon. It will be done when your whisk leaves trails across the surface. This process should not take longer than 30 minutes.

Note: The next two steps are quick and easily done as you whisk the sabayon.

4. Smooth the mascarpone with the back of a spatula or spoon to break up any lumps; this will help prevent overmixing when combining all the ingredients together.

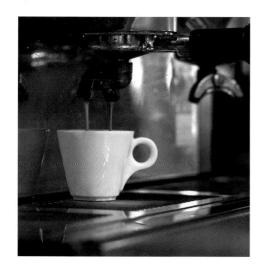

5. Measure out ½ cup of Marsala and set it next to the bowl of mascarpone.
6. When the yolk mixture is fully cooked, remove it from the double boiler and place it in a stainless steel bowl. Whisk it by hand to help speed up the cooling process and place it in the refrigerator until it is just slightly warm to the touch.
7. While the yolks are cooling, place the heavy cream in a mixing bowl and whisk until stiff. Store it in the refrigerator if the yolks are still not cool enough to combine.
8. Heat the gelatin according to the instructions on the package.[1]
9. As the gelatin is dissolving, pull the yolks and the cream from the refrigerator.
10. Mix the remaining Marsala into the mascarpone cheese, completely incorporating the two.
11. Add the yolk mixture to the mascarpone and fold until combined.

12. Quickly fold the whipped cream into the egg and cheese mixture. When almost combined, reserve 1 cup of this mixture. Be careful at this stage not to overmix.
13. Quickly stir the gelatin into the reserved egg and cheese to temper it.
14. Working rapidly, combine this portion back with the rest of the cream mixture.
15. Transfer the cream to a container and refrigerate it immediately. This filling will need to set for at least 4 hours to be firm enough to build the cake.

Tiramisu Assembly

Equipment needed: parchment, wax paper, or acetate strip—long enough to wrap around the cake and at least 5 inches tall; pastry bag; pastry brush; turntable; serrated knife; small sifter—a loose leaf tea ball works well; unsweetened cocoa powder; and a flat serving plate with a larger diameter than the cake

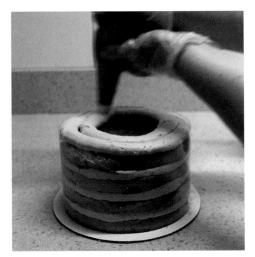

1. Take your cake and place it on the turntable. With a knife, cut off the dome on top of the cake. Look at the side of the cake and find the center point. Take your knife and score the cake all the way around, but do not cut it all the way through. Now look at the two sections and find their mid-points. Repeating the same as above, score the cake all the way around. This should result in four even layers of cake. If it does not, adjust the layers before you cut all the way through. Cut the cake, and set it on the counter.
2. Take the parchment paper, wrap it tightly around cake, and tape it in place. Make sure the parchment is straight; this will be your guide for the cake. Cut off any extra paper.
3. Carefully lift the paper off of the cake and place it on your plate. (At the bakery we use a clear acetate strip for presentation purposes, instead of parchment paper.)
4. Fill a pastry bag with mascarpone sabayon. Do not use a tip in the pastry bag; it will break down the cream. The pastry bag will help to create an even layer of cream.
5. Invert your cake and place it top-down on the counter. Take the bottom layer in one hand, cut-side up, and with your pastry brush, brush the cut side of this layer with the espresso. Place this layer, bottom down, inside the parchment ring. Make sure it is all the way on the bottom and that the parchment ring does not creep up.
6. Use the pastry bag, starting in the middle; in a circular motion, lay down the cream. Wrap the cream around and around until you are about ⅛ inch from the edge.

[1] *If using Signature Secrets, sprinkle it over the mixture when you are folding in the whipped cream.*

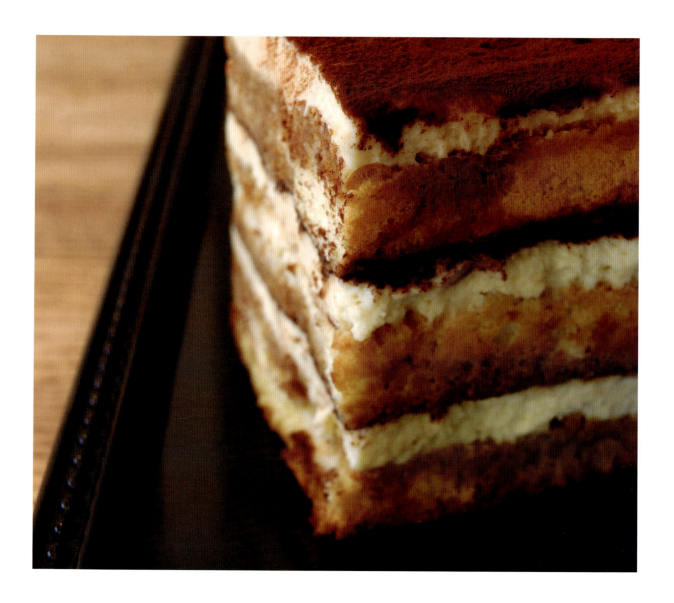

7. With the sifter, carefully sift cocoa powder on top of the mascarpone filling.

8. Take the second layer of cake, brush both sides with espresso, and gently place inside the parchment ring. Press this layer down very gently. Be careful not to push down on the layer too much, or the filling will be pushed out the side.

9. Repeat these steps with a layer of mascarpone, cocoa, a third layer of espresso-brushed cake, mascarpone, cocoa, and a final layer of soaked cake.

10. Finished the top of the cake with a thin layer of mascarpone.

11. With a clean cloth, carefully brush off any cocoa powder that may be on your serving plate.

12. Place the cake in the refrigerator to set, at least 2 hours.

13. When you're ready to present the cake, remove it from the refrigerator and put on your final garnish. At the bakery we use an off-set spatula to smooth out the top and finish with cocoa powder and espresso beans or chocolate curls.

14. After garnishing, carefully unwrap the cake, and it's ready to serve.

Lime-Coconut Cheesecake

Toasted Coconut Crust
1¾ cups shredded coconut
7 tablespoons white sugar
2 egg whites

Lime Curd
Yield: 3 cups
½ cup lime juice
⅔ cup white sugar
¼ teaspoon fine sea salt
3 whole eggs
6 egg yolks
10 tablespoons butter
1 teaspoon liquid chlorophyll

Cheesecake Batter
24 ounces cream cheese, room temperature
3 whole eggs
1⅓ cups white sugar
⅛ teaspoon fine sea salt
1½ tablespoons lemon juice
1 tablespoon vanilla extract
1⅔ cups sour cream, room temperature

Makes one 9-inch, or one 7-inch plus two 4-inch, or six 4-inch cheesecakes

Toasted Coconut Crust
Prep time: 10 minutes | Oven temperature: 350°F | Baking time: 20 minutes

1. Prepare your pans. Removable-bottom pans are preferable; if unavailable, use a springform pan. With a springform pan, you'll need to wrap the bottom with foil, that reaches at least two-thirds up the side of the pan. The cheesecake is baked in a water bath, and you don't want the water to slip through the seams on the pan. If you're only making 4-inch cakes, you don't need to put them in a water bath but you should have a pan of water in the oven while they're baking.
2. Toast the coconut in the oven until just brown.
3. Combine the egg whites and sugar in a large bowl and whisk until incorporated.
4. Add the toasted coconut and fold until fully incorporated. The crust will not come together but will hold its form when squeezed in your fist.
5. Measure out the appropriate amount of crust for your pan(s). Lightly spread the coconut to the edge of the pan(s) and press down with the back of your hand to ensure the crust is even from center to edge. To get a nice firm crust, it's important to tamp down the crust. You can do this with your hand if you press firmly. Or you can find an object with some weight that has a flat bottom, wrap it with plastic wrap, and press it into the crust.
6. Place the pan(s) the in oven and bake for 10 minutes.
7. Remove from the oven and tamp again, then put them back in the oven for another 8 to 10 minutes, until the crust is golden-brown.
8. Remove from the oven and let cool for at least 10 minutes. Now the crust is ready for the cheesecake batter.

Lime Curd
Prep time: 15 minutes | Cooking time: 20 minutes

1. Over a double boiler, combine the sugar and lime juice. Whisk the ingredients together to dissolve.

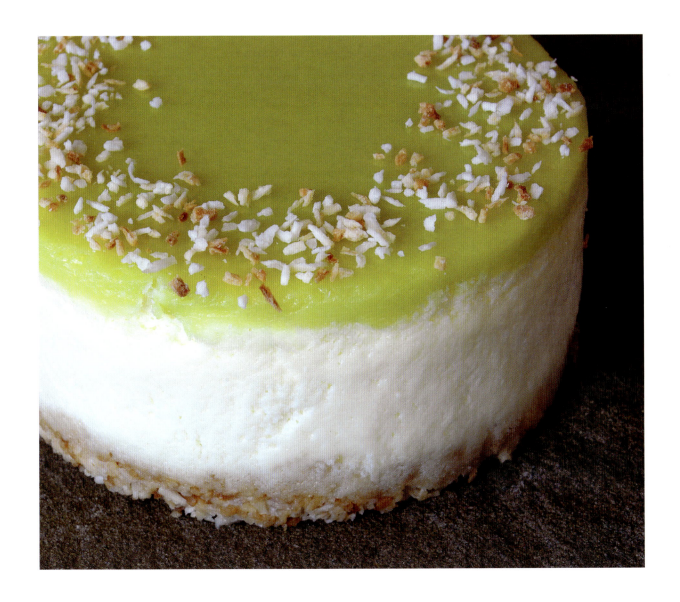

2. In a mixing bowl, whip the whole eggs, egg yolks, and salt into a uniform consistency.

3. While mixing, cut the butter into 1-inch cubes and set aside to come to room temperature.

4. Add the egg mixture to the lime juice and whisk constantly until thickened and a digital thermometer reads 170°F. After the foam dissipates, it will thicken quickly.

5. Remove from heat, add the butter chunks and liquid chlorophyll, and stir until completely incorporated.

6. Transfer to a storage container and cover with plastic directly on top of the curd; this will prevent it from forming a skin.

7. Allow it to cool for up to 30 minutes. When it's cool, pour a thin layer (¼-inch) on top of the cake. Allow the cake to set overnight in the refrigerator.

Note: If you're making the curd a day ahead, pull out what you think you will need and warm it enough to pour onto your cheesecake.

CHEESECAKE

Prep time: 30 minutes | Oven temperature: 330°F | Baking time: 4-inch - 30 minutes, 7-inch - 50 to 60 minutes, 9-inch - 70-plus minutes | Equipment needed: mixer with paddle, springform pans, baking dish large enough to place springform pan in, and aluminum foil

1. At least 30 minutes prior to mixing, pull the cream cheese, eggs, and sour cream from the refrigerator to warm.

2. Beat the cream cheese in a mixer until smooth. Frequently stop and scrape down the bowl and paddle attachment until the cream is smooth.

3. Beat in one egg at a time, scraping down the bowl between additions.

4. Beat in the sugar, salt, lemon juice, and vanilla until light and fluffy. Scrape the bowl and paddle a few times to ensure there are no lumps and the batter is consistent.

5. In a small bowl, measure out the sour cream and stir. This will help it combine in the batter without having to beat it, breaking down the volume.

6. Fold in the sour cream until fully incorporated.

7. Pour the batter into prepared pan(s). Place the prepared pan(s) inside a larger pan or baking dish. Cheesecake pan(s) must be able to sit flat in the bottom of the larger

pan. Once the cheesecake is in the pan, carefully pour water into the larger pan, creating a water bath. This will help the cake to bake evenly.

8. Place the pan and water bath in the oven and bake for the appropriate amount of time, depending upon the size of your cheesecake pan.

9. The cheesecake is done when it has reached 150°F. For a 9-inch cake or larger, let it reach a temperature of 160°F; it is done at 150°F but will be very hard to de-pan.

10. You will know the cake is done by pulling it from the oven and testing it in the center with a digital thermometer. Make sure not to insert the thermometer too far in, temping the bottom of the pan instead of the center of the batter. The cake will have puffed up and will no longer be shiny on top. It will still be very loose; that's okay as long as it has reached a temperature of 150°F.

Do not top cheesecakes immediately out of the oven. Let them cool for at least 40 minutes. When topping a warm cheesecake, avoid pouring curd directly in the center of the cake, try and pour in a circular motion around the edge. Cheesecake is always best if it is allowed to set overnight. It needs at least 6 hours to set, depending upon the size of the cake. The following day, remove the cake(s) from the pan(s), place on flat plate(s), touch up any of the curd that may have dripped down the sides, and garnish with toasted coconut.

Chocolate-Raspberry Cake

Chocolate Cake

3 cups plus 3 tablespoons all-purpose flour
1 cup plus 1 tablespoon white sugar
1½ cups brown sugar
1 cup cocoa powder, sifted
1½ teaspoons fine sea salt
2½ teaspoons baking soda
1½ cups warm water
¾ cup plus 1 tablespoon plus 1 teaspoon canola oil
1 tablespoon plus 1 teaspoon vanilla extract
1⅓ cups hot coffee
4 egg yolks
4 egg whites
⅛ teaspoon cream of tartar

White Chocolate Cream Cheese Frosting

24 ounces cream cheese, soft
½ cup plus 6 tablespoons butter, soft
2 tablespoons plus 2 teaspoons lemon juice
3 cups white melting chocolate

Raspberry Whipped Cream

2 cups heavy cream
2 tablespoons confectioner's sugar
½ cup raspberry preserves

Makes two 8-inch cakes

Note: this recipe will also make four 6-inch cakes

Death by Chocolate Cake

Prep time: 30 minutes | Oven temperature: 350°F | Baking time: 30 to 35 minutes

This is a sponge cake, so it's very important that your ingredients are at the correct temperature and that you get it into the oven as soon as the batter goes into the pans.

Preheat the oven. Gather your ingredients. It's very important that the eggs be at room temperature. Brew the coffee and set it aside. Gather your pans and pan spray, but don't prep the pans until the batter is together. If you're making a cake that is 10 inches or larger, line the bottom of the pan with parchment paper. Also grab an extra bowl (stainless steel or glass; ideally it would be an alternate mixing bowl) for your egg whites (*see step 5*).

1. Mix all of the dry ingredients on low in a mixing bowl with the paddle attachment. Break up as much of the brown sugar as possible.
2. In another large bowl, combine the water, oil, and vanilla.
3. Separate the eggs, putting the whole yolk into the bowl with the liquid. Put the whites into the clean bowl you have set aside. Make sure not to get any yolk into the whites, or the fat from the yolk will deflate the whites.
4. Measure out the coffee and add it to the liquid bowl, making sure the coffee stays warm.
5. Stop the mixer and add the wet ingredients to the mixing bowl. With a spatula, gently combine the wet and dry ingredients together. With the paddle attachment, slowly start the mixer. Mix together until all dry ingredients are incorporated and the sugar has dissolved, stopping to scrape the bowl a couple of times to ensure all is combined. It will be a very loose batter. Once it is mixed thoroughly, remove the bowl from the mixer. If you have a second mixing bowl that fits your mixer, use it for your egg whites. If not, pour your chocolate batter into a large bowl and wash and dry the bowl that fits your mixer, making sure there is no oil residue in the bowl.
6. Start to whip the egg whites on medium speed with the whip attachment. Once they start to froth, add the cream of tartar. Whip on

medium, then turn up to high. You are looking for the eggs to have soft to medium peaks, like the top of a soft-serve ice cream. The whites should still be glossy and smooth, not dry and stiff.

7. At this point, quickly and lightly spray your pans and check your oven temperature. Once you add your whites, the cake should go directly into the oven.

8. Fold the egg whites into the batter a third at a time. Make sure you're getting to the bottom of the bowl and the batter is all the same color. Try not to overmix at this point; you want as many of those tiny bubbles as possible. Pour the batter directly into the pan(s) and place them in the oven.

9. When done, remove the cake(s) from the oven and place the pan(s) on a wire cooling rack. Let cool in the pan(s) for 10 to 15 minutes. When you're able to handle the pan(s), place the palm of your hand on the top of the cake and invert it, removing the pan. Quickly grab the cooling rack and place it on the bottom of the cake, flipping it right-side up. Let the cake cool completely before cutting for assembly of finished cake.

Raspberry Whipped Cream

Do not do this step too far in advance, or the cream will lose its stiffness.[1]

1. Chill the mixing bowl and whip attachment in the refrigerator for 5 minutes.
2. Pour the cold cream into the bowl and start to whip it on medium speed.
3. As the cream starts to froth, add the confectioner's sugar and the raspberry preserves.
4. Whip the cream on medium until combined, then turn up to high to stiffen and add volume.
5. You're looking for the cream to be stiff enough to support cake layers.

Chocolate Ganache

Use recipe from the éclair section of the book. (*see page 53*).

[1] *Adding a ½ tablespoon of Signature Secrets to the cream prior to whipping will stabilize the cream and will help it not to lose its stiffness.*

White Chocolate Cream Cheese Frosting

When sourcing ingredients for the frosting, it's important to note that not all white chocolate sold in the grocery store is really white chocolate. If it says "white chips" instead of "white chocolate chips," it's not really chocolate and will not melt properly. White chocolate bars would also work; just break them in pieces so they'll melt more quickly. For this recipe, it's very important that your butter and cream cheese are warm but not melted.

1. Measure out the chocolate and place it in a double boiler set on medium. White chocolate will burn very easily, so stir frequently; if the water starts to boil, turn it down. White chocolate will also seize very easily if it gets any water in it, so make sure your bowl and spatula are completely dry. You want the chocolate to be melted but not very hot.

2. As the chocolate melts, start to beat the cream cheese and butter in a mixer until completely combined. Stop and scrape down the bowl and paddle a few times during this process.
3. The trick to this recipe is in adding the chocolate to the cream. If the chocolate is too hot and the cream is too cold, the chocolate will harden again, making chunks in your frosting. You can test this by taking a little chocolate on your fingertip and a little of the cream in your other fingers and rubbing them together. If the chocolate starts to harden quickly, wait until the temperatures are more balanced.
4. Adding the chocolate: Turn the mixer on to speed 1 and start to pour the chocolate into the cream. Do this quickly to avoid any chunking that may occur. Scrape down the bowl and paddle and mix again to completely incorporate.
5. Still on speed 1, slowly add the lemon juice. Do not add the lemon prior to the chocolate, or the cream will curdle. Once it's all combined, transfer it to a clean storage container; it is now ready to use. If the frosting is too loose, refrigerate until needed.
6. This frosting will get very hard in the refrigerator. When you want to use it again, pull it out to warm it (or put a small amount into a microwave safe bowl to warm consistently), and beat it in the mixer to regain the correct consistency for frosting.

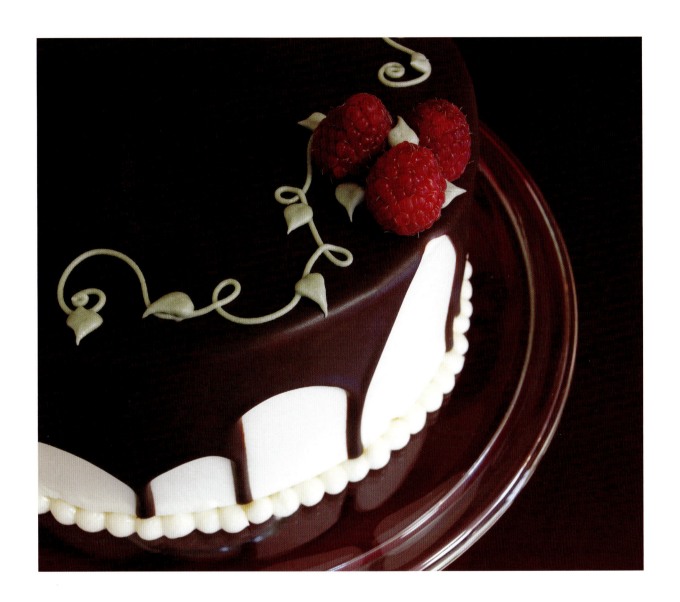

CHOCOLATE RASPBERRY CAKE ASSEMBLY

Equipment: cake turntable, cake spatulas (8-inch straight metal and a 6-inch off-set metal), cookie cooling rack that will sit inside a cookie sheet with sides, serrated knife, a cardboard round the size of the cake, a flat plate slightly larger than the cake, and a pastry bag with a #2 and #5 tip.

1. Prepare the raspberry whipped cream and place it in the refrigerator.
2. Take one cake and set it on the turntable. With a knife, cut off the dome of the cake. On the side of the cake, use the knife to mark the middle; with your knife steady and flat, turn the table so you mark the cake all the way around. Then, cut the cake, following that line. You should end up with two layers of cake of equal thickness. Take both layers and place them on the cardboard round, bottom-side down.
3. Repeat with second cake, but invert the layers, leaving them bottom-side up. If you're not going to assemble the cake immediately, wrap the layers with a piece of plastic wrap to ensure that they don't dry out.

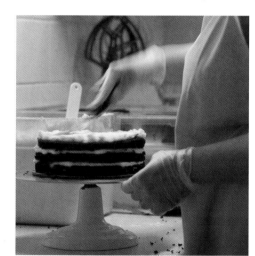

4. With all the layers from both cakes stacked, carefully invert them with the top side on the counter. Place the cardboard round and the bottom layer of the cake on your turntable. Place a dollop of cream in the center of the cake and with the small off-set spatula, spread cream to within an ⅛ inch of the edge of cake. This layer of cream should be slightly thinner than the layer of cake. Repeat with the following two layers, topping with the last layer, uncut side down. Make sure the cake is straight and centered on the board. Place the cake on a flat tray and place in the refrigerator to set up as you prepare your frosting.
5. When ready, remove from the refrigerator. If any raspberry cream has squeezed from the edges of the cake, clean it with one of your spatulas. If the frosting has just been made and is a good consistency (firm but spreadable, not soupy), put a little in a small bowl (this is so you don't get crumbs in the rest of your frosting) and apply a thin crumb coat using either spatula. Start by placing a dollop on the top center of the cake and spreading out to the edges. Whatever goes over the side, can be smoothed down the side of the cake. This coat of frosting is thin enough to see through; it's there to seal up the cake and keep crumbs from getting into the top layer of your frosting.

Note: if you made the frosting the day before, pull out what you think you will need and put it in a microwave-safe container. Warm it in the microwave only until soft enough to mix in your mixer. This step helps to melt the chocolate again. If the frosting appears to be a little

grainy, the chocolate isn't warm enough; warm it a little more and blend again in the mixer. If you've melted the frosting too much, return it to your refrigerator and wait for it to firm.

After you've applied a thin coat of frosting all over the cake and down over the edge of the cardboard round, pick up the cake with the small off-set spatula and place it on a flat tray. Put it into the refrigerator to set. Wait until this coat of frosting is set before you add the second coat, about 15 minutes.

6. Once the crumb-coat is set, use frosting that does not have crumbs in it to apply the final coat. This coat should be slightly thicker and if possible cover any cake that is peaking through. This layer should be as smooth as you can make it. Set it on the cooling rack that has the cookie sheet under it and place it in the refrigerator.

7. Pull out the ganache and warm it to a consistency that is easy to pour but not extremely hot. You can do this in the microwave or on the stove in a double boiler.

8. Once the frosting has set, pull the cake from the refrigerator and pour ganache directly in the center of the cake. Pour enough to spread over the entire top of the cake and down the sides, onto the pan. You can choose to cover the cake entirely or leave it with drips of ganache down the sides. Put the cake back into your refrigerator to set.

9. Take a clean, flat serving dish and place it on a counter next to your work area. Once the ganache has firmed, remove the cake from the refrigerator and lift it very carefully using a small off-set spatula; secure the cake when lifting by slipping your other hand under the cardboard. With the small spatula, go around the bottom edge of the cake to touch up the areas where the ganache has dripped all the way down.

10. Place the cake onto the serving dish and set back in the refrigerator.

11. Use your off-set spatula to scrape any ganache off the cookie sheet and return it to the container. Save to use on éclairs or on top of ice cream, etc.

12. For a garnish, we top ours with a thin vine of frosting and a few fresh raspberries. We also finish the bottom border of the cake using a piping bag with a #5 tip, making a row of "pearls" between the chocolate drips.

13. Refrigerate the cake to set the final decorations. Make sure to pull it out 30 to 45 minutes before serving, as chocolate tastes best at room temperature.

Appendix

Ingredient Sourcing

MARSALA WINE, SWEET—Local liquor store. Remember, if you wouldn't drink it, you shouldn't cook with it—buy quality.

LIQUID CHLOROPHYLL—Health food store in the supplement section. Used as a natural food coloring in lime curd or frosting.

ASCORBIC ACID—Health food store, non-buffered vitamin C powder.

WHITE MELTING CHOCOLATE—Local grocery store, White Chocolate Bars by Ghirardelli. Must say "white chocolate"; beware of any that say "white chips," as they aren't chocolate and won't melt properly.

GELATIN POWDER—Sold at most grocery stores.

SIGNATURE SECRETS—www.signaturesecrets.com; this is an all-natural stabilizer derived from wheat. It dissolves in both hot and cold products.

INSTANT ACTIVE DRY YEAST—Also called "rapid rise," sold in most grocery stores, looks like small sticks.

MASCARPONE CHEESE—Sold at most grocery stores in the specialty cheese section.

CLEAR ACETATE STRIPS—www.bakedeco.com

ORGANIC CANE SUGAR—Found in all health food stores and larger grocery stores. This ingredient is also known as raw sugar or evaporated cane juice.

RICE FLOUR—Local health food stores and most larger grocery stores.